Challenge of the Machine. In this day and generation we must recognize that this transforming force whose outward sign and symbol is the thing of brass and steel we call a machine, is now grown to the point that the artist must take it up, no longer to protest. Genius must dominate the work of the contrivance it has created. This plain duty is relentlessly marked out for the artist in this, the Machine Age. He cannot set it aside, although there is involved an adjustment to cherished gods, perplexing and painful in the extreme, and though the fires of long-honored ideals shall go down to ashes. They will reappear, phoenixlike, with new life and purposes.

FRANK LLOYD WRIGHT
The Art and Craft of the Machine, 1904

HERBERT READ

the principles of industrial design

art and industry

Indiana University Press • Bloomington

Copyright *1953* *by* *Herbert* *Read*

acknowledgments

A general acknowledgment is due to those manufacturers and their agents who not only gave me permission to reproduce articles for whose manufacture they were responsible, but in many cases also supplied me with the photographs. My particular thanks for photographs or information are due to the authorities of the British Museum, the Science Museum, the Victoria and Albert Museum, the Museum of Modern Art (New York), the British Broadcasting Corporation, the Design and Industries Association, The Council of Industrial Design, the Institute for Decorative and Industrial Art (The Hague), the editors of the *Architectural Review* and *Design for Today,* Noel Carrington, Serge Chermayeff, F.R.I.B.A., Wells Coates, Ph.D., B.Sc., B.A., Raymond McGrath, F.R.I.B.A., J. Leslie Martin, Ph.D., F.R.I.B.A., P. Morton Shand, and Ronald Thompson, B.Sc. I owe a special debt to the late Laszlo Moholy-Nagy, who gave me considerable help in procuring the photographs from Continental sources, and to Mrs. Primrose Boyd, who has helped me to procure additional illustrations for this revised edition.

contents

illustrations

METALWORK
Figures 22, 35–64, 72, 73, 79, 82
Fig. 22: English mug; 17th century. 35: Sheffield teapot, ca. 1780. 36: Coffee service; by Marianne Brandt, Bauhaus, Germany. 37: Saucepans; Lalance and Grosjean Mfg. Co. 38: English wrought-iron grill, 13th century. 39: Gas meter; by Misha Black and J. Napier Proctor. 40: English mug and cream jug, 18th century. 41: English tankards, 17th and 18th century. 42: Coffeepot, 1705–6; by Isaac Dighton. 43: Bowls; by Gross and Esther Wood, Harold Elberg. Cigarette box; by Paul Hagenaur. 44: Teakettle; by Lurelle V. A. Guild. 45: Tumblers; Polar Ware Co. 46: Mexican baking dish. Frying pan; Corning Glass Works. 47: Pressure cooker; by Raymond Loewy Associates. 48: Pendant light fitting; by Gaby Schreiber. 49: Table lamp; by H. Gitlin. 50: English knives, 16th century. 51: Knives; Hermann Konejung, Germany. 52: English spoon, 1665–6, and French spoon, 15th century. 53: Serving spoons; Württembergische Metallwarenfabrik, Germany. 54: English smokers' tongs, 18th century. 55: Scissors; H. Boeker and Co., Germany. 56: Aluminum garden rake; Kenco Products Co. 57: Callpers; Brown & Sharpe. 58: Salad basket; by M. Schimmel. 59: Electric iron; by Sadie Speight. 60: English pewter measure, 16th century. 61: Electric washer; by Parnall Ltd. 62: Duplicator; by Roneo Ltd. 63: Canteen wagon; Berndorfer Metallwarenfabrik, Germany. 64: Clothes and dish washing machine. Thor Appliances Ltd. 72: Chair; by Serge Chermayeff. 73: Chairs; by Mies van der Rohe. 79: Chair; by Charles Eames. 82: Chair; by E. Saarinen.

WOODWORK
Figures 65–71, 74–78
Fig. 65: English table, ca. 1770. 66: Desk; Gordon Russell Ltd. 67: Dining-room furniture; B. Cohen and Sons, Ltd. 68: Radio-gramophone; by Trevor Dannatt. 69: Chair; by E. Saarinen and Charles Eames. 70: English armchair, ca. 1800. 71: Armchair; by "Plan" Ltd. 74: Chair; Ernest Race Ltd. 75: Chair; Ernest Race Ltd. 76: Chair; by Robin Day. 77: Chair; by Peter Hvidt and O. Molgard Nielsen. 78: Chairs; by Alvar Aalto.

PLASTIC
Figures 80, 81, 83–85
Fig. 80: Chair; by E. Saarinen. 81: Chair; by Charles Eames. 83: Lighting fittings; Benjamin Electric Ltd. 84: Radio cabinet; by Serge Chermayeff. 85: Mixing bowl set; Plas-Tex Corp.

PART 3

PART 4

preface to the Midland Book edition

Since the original publication of this book, there has been no spectacular advance in the standards of design—indeed, in some categories, in spite of one or two brave exceptions, there seems to have been a retrogression. There have been immense advances in engineering products such as airplanes and—in spite of many features that are still deplorable—in automobile design. It is rather in those arts where the personal taste of the consumer is involved—textiles, wallpapers, ceramics and furniture—that something in the nature of a reaction has set in. It would seem that the general effect of the Second World War, and of the economic impoverishment of most countries that was its consequence, has been a failure of nerve. Journals that were formerly progressive and experimental in their outlook have indulged in sophisticated antiquarianism, and a justifiable dissatisfaction with the bleakness of a pioneering functionalism has turned into an unashamed nostalgia for "ornament" and "period style." But there have been no defections among the leaders of the modern movement, and a new generation of architects and industrial designers has now appeared. There remains the massive inertia represented by manufacturers and consumers, two intangible groups that combine to "pass the buck" to each other—the buck in this case being the responsibility for the perpetuation, in nearly every trade except engineering, of design that has neither beauty nor efficiency.

This vicious circle can be broken only by education—the general education of the public and more particularly education in the primary schools. Groups of educators and teachers fully conscious of what is needed in this respect

are active in most countries now, but they need more encouragement from official sources. The Council of Industrial Design, established in Great Britain in 1944 and specifically charged with the improvement of design in industry, is a pattern that other countries might follow with benefit, though it must never be forgotten that for taste to be genuine it must be a growth of the soil, an instinct of the people, and not a dictate of government.

This book was originally published in England in 1934 and since that year has been repeatedly revised and reprinted. The first American edition was based on the third (revised) English edition (1953), but completely reset; the illustrations have been augmented to include a representative selection of recent American products. It was my intention from the beginning, however, to survey industrial design on a world-wide basis. From time to time the standard of design in one country may be leading the world, but there are no specifically national trends in industrial art; the same means of production prevail everywhere, and the general principles which I have tried to establish in this book are of universal application.

<div align="right">H.R.</div>

March, 1961

introduction

Once again I warn you against supposing, you who may specially love art, that you will do any good by attempting to revive art by dealing with its dead exterior. I say it is the "AIMS OF ART" that you must seek rather than the "ART ITSELF"; and in that search we may find ourselves in a world blank and bare, as a result of our caring at least this much for art, that we will not endure the shams of it.—WILLIAM MORRIS: *The Aims of Art*

The aim of this book may be stated quite briefly. For more than a hundred years an attempt has been made to impose on the products of machinery aesthetic values which are not only irrelevant, but generally costly and harmful to efficiency. Those aesthetic values were associated with the previously prevailing handicraft methods of production, but they were not essential even to these. Actually they were the superficial styles and mannerisms of the Renaissance tradition of ornament. Nevertheless, the products of machinery were at first judged by the standards of this tradition, and though there have been attempts, notably the one led by Ruskin and Morris, to return to the more fundamental aspects of handicraft—that is to say, to the forms underlying the ornament—yet the problem in its essentials remains unsolved. For the real problem is not to adapt machine production to the aesthetic standards of handicraft, but to think out new aesthetic standards for new methods of production.

In other words, what is required as a preliminary to any practical solution of the division existing between art and industry is a clear understanding, not only of the processes of modern production, but also of the nature of art. Not until we have reduced the work of art to its essentials, stripped it of all the irrelevancies imposed on it by a particular culture or civilization, can we see any solution of

the problem. The first step, therefore, is to define art; the second is to estimate the capacity of the machine to produce works of art.

The work of art is shown to be essentially formal; it is the shaping of material into forms which have a sensuous or intellectual appeal to the average human being. To define the nature and operation of this appeal is not an easy task, but it must be faced by anyone who wishes to see a permanent solution of the problem that concerns us.

The problem, that is to say, is in the first place a logical or dialectical one. It is the definition of the normal or universal elements in art.

It is then complicated by the purposes which the objects we are shaping have to serve. That is to say, we are concerned, not with the works of art whose only purpose is to please the senses or intellect, but with works of art which must in addition perform a utilitarian function.

One false theory assumes that if the object in question performs its function in the most efficient way possible, it will *ipso facto* possess the necessary aesthetic qualities. To this argument we must reply that an object which functions perfectly may, and probably will, possess aesthetic qualities, but that the connection is not a necessary one. Aesthetic values are absolute or universal values to which an object, restricted by its function to a particular form, may approach; but by very reason of its particularity, cannot inevitably assume. In other words, art implies values more various than those determined by practical necessity.

The people concerned with the production of industrial objects are not normally interested in such metaphysical distinctions; but just as the sciences of physics and chemistry are necessary to the material and structural side of their productions, so the science of art is necessary to the formal

side; and this problem of the relation of art to industry will never be solved unless industrialists are willing to consult the expert in the theory of art as willingly as they consult the expert in chemistry or physics. The study of art is an extremely exacting occupation, calling for a wide range of faculties and specialist knowledge, and for the most logical and disinterested thought. It is no exaggeration to say that years of discussion have been wasted, and many markets lost, simply because the difficulty of the subject has not been recognized, and the proper authorities have not been consulted.

In reality, the situation has been more desperate still, for the proper authorities have not existed. In English-speaking countries, at any rate, there has been, until recent years, no fundamentally serious study of the problems of art; and if men of the intelligence of Ruskin and Morris approached the subject with the grossest illusions and prejudices, it is hardly to be expected that practical men of affairs should solve the problem.

But actually it is the practical men of affairs who have solved the problem. It is the engineers who built the Forth Bridge and the Crystal Palace, who more recently evolved the form of the automobile and the airplane, who first unconsciously suggested the elements of a new aesthetics. Their suggestions were picked up by more conscious architects and designers, and gradually, in a few pioneer spirits, the old and inappropriate traditions were discarded, and a new tradition, based on practical realities, was evolved. This tradition still needs formulation, and in the pages which follow I have attempted to give the first sketch of such a formulation. But we are still in the stage of experiment and research—practical experiment and research—and it will be many years before these first principles can be given any

full systematic exposition and illustration. At present one must generalize from analogies in the past, and on very slender and inadequate evidence of the present day.

The objection which I must meet in this Introduction relates to the validity of that evidence. If we reject the aesthetic faith of Sir Joshua Reynolds, Ruskin, Morris, the Royal Academy, the Royal College of Art, and fifty-eight thousand deluded art students, and turn to the work of a few practical engineers and technical designers, it will be said that work so unconscious of aesthetic purpose cannot for a moment be compared with craftsmanship based on the tradition of five centuries. It will be seen that in the first place I question the accepted interpretation of this tradition; that I distinguish sharply between the humanistic and formal elements in such art; and that then I would seem to reject the whole humanistic tradition, at least in so far as it concerns objects of use.

If I do so, it is because I am conscious that there is a subtle distinction between "humanistic" and "human"; and conscious, too, that beyond the so-called humanistic tradition there is an older tradition which offers many analogies to the new tradition emerging today. In the twelfth and thirteenth centuries, as in the fifth century B.C., there existed, in Northern Europe and in Greece respectively, phases of architectural development, and of industrial design generally, that have never been excelled in history. There is one significant fact about such periods: they are without an aesthetic. What they did, they did as the solution of practical problems, without taste, without academic tradition. There is no medieval treatise on art; it is barely mentioned in the whole of the scholastic philosophy as a separate category, and when mentioned, is always regarded as a practical activity, whose aim is clarity, order, harmony, and

functional integrity. The position is similar in Ancient Greece, and not until Greek art is decadent does anything in the nature of a conscious aesthetic find expression.

Today we are entering on such another phase in the history of art. Social and economic reorganization, the introduction of new materials which revolutionize the structural principles of building, the development of transport and communications, all these and similar events have created innumerable practical problems; and the immediate need is the solution of these problems in the most efficient fashion. If the urgent problem is the transformation of a million slum dwellings into cities of order, light, health, and convenience, the men who will be engaged on the practical problem of such a transformation will find questions of ornament and decoration singularly futile and academic—a waste of time and money. Their problem is not academic, but human and rational. They have to design houses which embody an ideal of decent living on a communal scale; to do this they will need imagination and science. Imagination and science— what more has any great work of art ever required? In the solution of the immediate practical problems of the day, all the necessary opportunities for a great tradition of design exist. If that tradition is not realized, it will be due to the imposition of false and irrelevant ideals of art.

These false ideals are for the most part fostered by our academies, institutes, and schools of art. I am almost forced to the conclusion, when I come to consider the problem of education in this book, that on the whole we should benefit from the total abolition of all academic instruction in art; that the only necessary instruction is technical instruction, out of which the practical questions of design automatically arise. But if academic education may with benefit be abolished, another form of education, aesthetic education, or

the education of sensibility, must be developed. The general principles of harmony and proportion, and the development of sensuous and intellectual perceptivity, must be taught on a new and extensive scale, especially at the elementary stage of education. That immense difficulties exist in devising such education must be admitted; a new pedagogic method is required.* But I am convinced that the instincts for the appreciation of abstract form are widely diffused, and some evidence of this fact may be derived from one of those popular extensions of language which are so significant and so little observed. I refer to the very general use of the word "streamline" and its derivatives. Its origin is, of course, technical and scientific; it is a term used in hydrodynamics for a line drawn from point to point so that its direction is everywhere that of the motion of the fluid. From this severely scientific use, it was extended to denote the shape of a solid body designed so that it meets with the smallest amount of resistance in passing through the atmosphere—for example, a motorcar or airplane. But the use is now much more extensive, and "streamlined" is popularly, if inaccurately, used as a term of approval for the design of any object of daily use. The point I wish to make is that by the use of such an expression the man-in-the-street is betraying his instinctive aesthetic judgments— aesthetic judgments which owe nothing to the standards of traditional taste and academic art—judgments which are, in fact, evidence of a new aesthetic sensibility. The same kind of sensibility permeated the societies that built the Parthenon and the cathedrals of the Middle Ages, and such a sensibility will eventually create comparable monuments of art for the societies of the future.

* Since this was written, I have explored these pedagogic questions in another book, *Education Through Art* (Pantheon, 1958).

PART 1

THE PROBLEM IN ITS HISTORICAL

AND THEORETICAL ASPECTS

Our capacity to go beyond the machine rests upon our power to assimilate the machine. Until we have absorbed the lessons of objectivity, impersonality, neutrality, the lessons of the mechanical realm, we cannot go further in our development toward the more richly organic, the more profoundly human.—LEWIS MUMFORD: *Technics and Civilization*

Since the introduction of machine methods into industry a problem has existed which has never been adequately solved. By the machine we mean an instrument of mass production. In a sense, every tool is a machine—the hammer, the ax, and the chisel. And every machine is a tool. The real distinction is between one man using a tool with his hands and producing an object that shows at every stage the direction of his will and the impression of his personality; and a machine which is producing, without the intervention of a particular man, objects of a uniformity and precision that show no individual variation and have no personal charm. The problem is to decide whether the

objects of machine production can possess the essential qualities of art.

A secondary problem arises out of this one. If we decide that the product of the machine can be a work of art, then what is to become of the artist who is displaced by the machine? Has he any function in a machine-age society, or must he reconcile himself to a purely dilettante role—must he become, as most contemporary artists have become, merely a society entertainer?

the Industrial Revolution

The machine age is almost exactly a hundred years old. The steam engine, the spinning jenny, the weaving machine, were all invented toward the end of the eighteenth century. The revolution in practical life that followed these inventions was, historically speaking, of an amazing suddenness. "It probably exceeded in suddenness," says one historian, "the metamorphosis effected at any previous transition from one ethnic period to another." But naturally it took a generation of men to build the machines, to install them, and carry out the consequent reorganization of industry. And the displaced human element resisted. The Luddite riots of 1811 and 1816 mark the acute stage of this resistance. All resistance overcome, the machine multiplied in expanding markets. Any surviving elements of craftsmanship were gradually eliminated from the process of production. By 1830 the machine age in all its power and significance was fully and finally established.

With the economic and social problems thus created we are not now concerned. They too remain unsolved.

first formulation of the problem

The immediate problem, a hundred years ago, was how to control the machine. It was a monster devouring raw materials at one end and turning out at the other end the finished article. But the finished article must appeal to the potential purchaser by its elegance, its decoration, and its color. Art, the capitalists of that age already realized, was a commercial factor. Other things being equal, the most "artistic" product would win the market. Such an obvious truth entered into the consciousness of no less a person than Sir Robert Peel, who was, let it be remembered, not only a great statesman, but an industrial magnate whose vast power and fortunes were founded on the spinning jenny. On April 13, 1832, he raised the matter in the House of Commons, on a proposal in the Miscellaneous Estimates to build a National Gallery. It was a very significant occasion. Not only was art for the first time admitted into an official discussion of economic affairs, but the foundations were then laid to a policy for dealing with the matter which is fundamentally false and futile. Let me quote from the official records of the House of Commons a few of the opinions then expressed by members of Parliament. Sir Robert Peel himself said that "motives of public gratification were not the only ones which appealed to the House in this matter; the interest of our manufactures was also involved in every encouragement being held out to

the fine arts in this country. It was well known that our manufacturers were, in all matters connected with machinery, superior to all their foreign competitors; but, in the pictorial designs, which were so important in recommending the productions of industry to the taste of the consumer, they were, unfortunately, not equally successful; and hence they had found themselves unequal to cope with their rivals. This deserved the serious consideration of the House in its patronage of the fine arts. For his part, although fully aware of the importance of economy, and most anxious to observe it, he thought this was the occasion for liberality, and that the House would do well to grant freely a sum of £30,000 for the construction of a suitable edifice for the reception of our noble national collection of pictures."

There were other speeches of the same nature. "Lord Ashley observed, that the patronage of works of science and art, such as the calculating machine of Mr. Babbage, had collateral advantages. Some improvements in machinery had lately taken place in Glasgow from the contemplation of that machine. He considered that the erection of a gallery would be extremely beneficial for artists and mechanics to resort to, and he had reason for believing that it would be frequented by the industrious classes, instead of resorting to alehouses, as at present.

"Mr. Hume thought, that the greatest advantage might be gained in the improvement of our manufactures, and at very little expense. There was only one man at Coventry who was at all proficient in forming designs for silks, and we had invariably to copy from foreigners in articles of taste, although our machinery was so far superior. At Lyons there was a School of Design, with numerous students, entirely for the purpose of improvement in patterns and

articles of taste. Hence the superiority of the French in this respect to our manufacturers.* He, therefore, was an advocate for the nation to erect a proper building, and he thought such a one could be had without putting the public to any expense."

So our leaders in politics and industry spoke a hundred years ago. So, to a large extent, they speak today. A hundred years ago, as a result of these deliberations in Parliament, it was decided that a committee should be appointed. We are still appointing committees and councils to deal with the same problem. Underlying the deliberations of all these bodies is a fallacy which inevitably does more harm than good. It is a fallacy about the nature of art. A hundred years ago our manufacturers decided that since they must have art, they would buy it like any other commodity, and apply it to their manufactures, even to the machines themselves. And so they bought art, art of all kinds and periods, and applied it; they mixed the styles and muddled the periods, but that was their claim to originality; and to give the public the best value for their money, they piled it on as thick as it would go.

But first, as I have said, an official committee was appointed. It was known as Mr. Ewart's committee and began its sittings in June 1836. "It examined manufacturers, connoisseurs, picture-cleaners and dealers, Royal Academicians and artists. Its report adverted to the little encouragement hitherto given to the arts in this country, to the close

* Cf. "At L'Ecole des Beaux Arts de Lyon there is ample evidence of the effective work that can be done by a school in close touch with local industry. . . . The manufacturers keep in close touch with the school. They visit it regularly, and, on the recommendation of the teacher, take students to fill vacancies in their design rooms. . . . If they show any aptitude they can command better than ordinary wages." From the Board of Education Educational Pamphlet No. 75, *Design and the Cotton Industry,* published 1929.

connection between arts and manufactures, and the want of means for instruction in design in our principal seats of manufacturing industry: and suggested, in addition to the Normal School of Design, which the Government had now taken a vote for establishing, local schools to be assisted by grants, the formation of museums and galleries of art, and further, the formation of a cheap and accessible tribunal for the protection of invention in design. They made many other recommendations, and in conclusion they submitted, that in the completion of great public buildings, the arts of sculpture and painting might be called in for the embellishment of architecture, and expressed their opinion that the contemplation of noble works in fresco and sculpture is worthy of the intelligence of a great and civilised nation." * As a result of this committee's deliberations, art schools were opened, museums were founded, and exhibitions were organized.† For the Queen's Consort a *man of taste* was found, and he busied himself almost exclusively in this great task to discover the best art of all periods, to teach it in schools and colleges, and apply it, always *apply it*, to the productions of industry.

The fallacy underlying the whole of this movement is by no means yet fully exposed. In the minds of our manufacturers, underlying the activities of our art schools, is still the supposition that art is something distinct from the proc-

* Note to the *Autobiography and Memoirs of Benjamin Robert Haydon.* Ed. Tom Taylor. New edition, London, 1926, Vol. II, pp. 601–2.

† From 1937 onward, specimens of manufactures, models, casts, prints, and other examples were purchased out of public moneys as the necessary equipment for instruction in design and ornamental art in the Schools of Design instituted in London, Birmingham, and Manchester. In 1852 a Museum of Ornamental Art was founded at Marlborough House, and in 1856 this was moved to specially constructed buildings at South Kensington. This museum developed into the present Victoria and Albert Museum. For further historical particulars see the *Guide* on sale at the Museum, and *The History of the Victoria and Albert Museum*, by C. H. Gibbs-Smith and Katharine Dougharty (London, 1952).

ess of machine production, something which must be *applied* to the manufactured object.

"fine" and "applied" art

The fallacy, however, did not begin with the machine age. The actual phrases "Fine Art" and "Applied Art" may be largely the creation of the machine age, but the underlying distinction is a product of the Renaissance. Before the Renaissance, the so-called Fine Arts (architecture, sculpture, painting, music, and poetry) were not explicitly named, nor distinctly recognized, as a separate class; even in classical Greece there was only one word, *tekhne,* for both kinds of art. That is not to say that there is no ground for the distinction, but before we investigate its validity, let us see how the distinction arose.

Let us first realize that the period between the end of the Middle Ages and the present day—a period of about five hundred years—is, in the history of art, a relatively short and insignificant period. Only by preserving some sense of historical perspective can we possibly arrive at a trustworthy generalization about the nature of art.

The use of the term "Fine Arts" is closely bound up with the history of academies of art, which are usually academies of *fine* art.* The first use of the phrase in English recorded by the *Oxford English Dictionary* is in 1767. The Royal Academy was founded in 1768. It was, of course,

* Since the appearance of the first edition of this book, Dr. Nikolaus Pevsner has published an admirable history of these academies which throws much light on the social aspects of art (*Academies of Art—Past and Present,* Cambridge University Press, 1940).

preceded by similar academies abroad—at Vienna and Bologna, for example—and all of these academies had their prototype in the Royal Academy of Painting and Sculpture, founded at Paris in 1648. Under the auspices of that Academy, in the year of its foundation, the first public exhibition of paintings and sculpture was held.

We are getting somewhere very near the source of the distinction between the "fine" and "applied" arts, but I think we must trace it still further back. Academies do not spring fully formed out of the brain of a statesman—a Colbert or a Mazarin. Actually the Paris Academy represents the public recognition of a practice which had been slowly growing during the previous two centuries. That practice was an inevitable accompaniment of the general development of humanism.

In the latter part of the Middle Ages there grew up the custom of insinuating, into works of art designed for some utilitarian or structural purpose in the fabric of a church, the portrait of the donor of the particular work. In any series of works of art—say altarpieces or stained-glass windows—you may observe how during the fourteenth and fifteenth centuries the portrait of the donor gradually grows in size and importance, until, in the sixteenth century, as in a typical picture like Holbein's "Meier Madonna" at Darmstadt (about 1527), the donor is painted on the same scale as the sacred figures, and even comes to dominate the whole composition. That development has a parallel in the character of illuminated manuscripts over the same period. Originally the illuminations in a manuscript were conceived strictly as decorations subsidiary to the text, and as part of the book as a book. They were incomplete and meaningless when divorced from the book. But gradually during this same period the illuminator began to conceive his

decoration *as a page,* complete as a page. It was then but a logical step to divorce the illumination from the book, and to paint on separate panels. In this manner, toward the end of the fourteenth century and during the fifteenth century, the panel picture came into existence. The first panel pictures—English pictures like the Wilton Diptych or the portrait of Richard II in Westminster Abbey, for example—are actually enlarged pages of the manuscript illuminator's art. It needed only the paganism of the Renaissance to make a further divorce between such pictures and any sacred or utilitarian intention; and precisely that complete separation was made by a painter like Giorgione (1477-1510). Social developments co-operated with this tendency—the growth of wealthy oligarchies, the diffusion of culture, the growth of a purely secular culture—and the picture in itself became a desirable object, either as a record of the personality of the owner, or as a decoration to his house, or even as an emblem of his wealth. In this manner the conception of the cabinet picture was finally formed and fully realized.

I am not suggesting that this was necessarily an illegitimate development. As a distinct category, the cabinet picture has every right to exist. We might speak of chamber painting just as we speak of chamber music; and just as such music is music divorced from its original purpose as an accompaniment to the dance, the march, or the religious service, to become a self-consistent unity, the satisfaction of an appetite for sweet sound, so painting, as Pater said in his essay on Giorgione, becomes an art aspiring to the same freedom from purpose, the same purity of delectation.

growth of the humanistic concept of art

If such art had remained distinct in its sphere, all might have been well. But the whole development of civilization from the sixteenth century onward, more particularly the growth of humanism and the declining cultural significance of the Church, forced the artist into this one channel of expression. Civilization insisted on a specialization of artistic functions. Whereas formerly the artist had been essentially an artificer, a man who was ready to turn his skill and sensibility to any account—to be architect, sculptor, painter, or craftsman indifferently, according to the need—now he was compelled to specialize on one or the other of these activities. Actually a complete distinction was henceforth to be made between the artist who made things to satisfy a practical purpose, such as the builder and the architect, and the artist who made things (essentially non-utilitarian) for the delectation of individuals.

Then round this cabinet or private art, and fed by the type of learning which the Classical Revival encouraged, there sprang up a tradition of connoisseurship or dilettant-ism, based on the knowledge and appreciation of such works of art. This tradition is known to us as *Taste,* or *Good Taste,* and to it, I think, we owe all the confusion of values that has existed since the sixteenth century until the present day. Taste, in all its incompleteness and exclusiveness, has been made the measure of industrial art, of the art of the machine age.

humanistic and abstract art

I want now to look at this distinction between cabinet art,
or pure art as it is sometimes called, and the useful arts
from another point of view. Every man, even the most
primitive, has two kinds of needs—the practical and the
spiritual. He must build shelters, make tools and weapons,
weave clothing, and so forth; from this point of view he Is
essentially a *maker*. His spiritual needs are much more
complicated and, at any rate in their outward form or
expression, vary very much from age to age; but funda-
mentally all this side of man's life excites *feeling* and invites
response.

The man who makes becomes potentially, or partially,
an artist the moment the things he makes express feeling
and invite response.

To give material or plastic expression to his inner feelings
is a necessity; it is one of the facts that distinguish man from
the animals, and wherever we find man, we find some kind
of plastic expression. Art is a biological necessity, but the
range of feelings to which man can, and will, give expres-
sion is almost endless in its variety, and we cannot proceed
far in reasoning unless we impose some hierarchy of values
upon this endless variety. In a painting by Giorgione, for
example, there are the elements of formal sensory appeal
(in the composition and color) and of pictorial appeal (in
the nature of the subject depicted). These two elements
should be closely interrelated—"the constituent elements of
the composition," as Pater says, "are so welded together,

that the material or subject no longer strikes the intellect only; nor the form, the eye or ear only; but form and matter, in their union or identity, present one single effect to the 'imaginative reason,' that complex faculty for which every thought and feeling is twin-born with its sensible analogue or symbol." But, in addition, in many types of art there is a third element which is neither measurable nor imaginative, born neither of thought nor of feeling, but which we might describe as "intuitional" or "irrational."

We have, therefore, three constituent elements to distinguish:

(1) formal elements of dimension and proportion which have a direct sensory appeal;

(2) elements of emotional or intellectual expression which may be combined with the formal elements;

(3) elements of an intuitive or subconscious nature.

The nature of the appeal inherent in the second element is obvious; it is the appeal of all the pictorial and figurative arts whatsoever, and because art which concentrates on this kind of appeal has been the typical preoccupation of artists in the so-called humanistic periods of civilization (the Graeco-Roman and Renaissance periods), it is called Humanistic Art.

The nature of the appeal inherent in the other elements will be analyzed in more detail in the next section, but those who do not care to go into such detail (and who may therefore wish to omit reading the next section) should note that in so far as these elements are not humanistic, they will be distinguished as Abstract. I realize that the word "abstract" is a difficult and unsatisfactory word; but more precise terms, such as "nonfigurative," "nonpictorial," "nonrepresentational," are not only merely negative, but actually too limited to cover all the possible aspects of the

elements in question. The various elements in an "abstract" work of art—the materials, their colors, textures, and dimensions—are actually "concrete," but in so much as they do not constitute a work of art until given an intellectual organization, this is no valid objection to the use of the word "abstract." I think, therefore, that the word "abstract" must be used, even if it means giving it a connotation that the dictionaries do not yet sanction.

the nature of form in art

The word "form" is regularly used in all modern discussions about art, but it is not often realized how complex are the notions conveyed by the word—how many different notions the word may convey, and therefore how vaguely it conveys any notion at all. I have already dealt with some aspects of the question as they affect the arts of painting and sculpture in my book *Art Now*, and there is a more detailed and specific definition of the term in my introduction to a volume illustrating the sculpture of Henry Moore (Lund Humphries, 1944). I would like in this section to make a somewhat schematic summary of the whole question, so that the reader may at least have some clear idea of the problems involved.

By the form of a work of art we mean simply its shape. Even the composition of a painting is merely a reduction to two dimensions of the three-dimensional aspect of things—though for that matter a two-dimensional composition is also a "shape." But the possible number of shapes is, of

course, infinite, and the artist, in selecting one particular shape, is governed either by law or by instinct.

Early man, we may assume, in making his implements was governed entirely by considerations of utility. A hammer had to have a blunt head, an arrow a sharp point, and so on. Form evolved in the direction of functional efficiency.

But a moment arrives in the development of civilization when there is a choice between equally efficient objects of different shape. The moment that choice is made, an aesthetic judgment has operated. What are the motives that lead man to prefer one shape to another?

Such motives, we can say, may be either conscious or unconscious. Either man makes his selection because he believes, after rational thought and observation, that one shape is "better" than another; or he does not think about it at all—he acts, as we say, intuitively.

Since we have excluded the motive of efficiency, the rational choice must be determined by some consideration external to the object itself. This is likely to be a consideration derived from the observation of objects in the natural world. Now, at a very early stage in the history of human thought, man discovered that certain proportions— that is to say, certain shapes—were constant in nature. We can only speculate on how these discoveries came to be made, but made they were, and on them was based a whole philosophy of the universe. This philosophy reached its most definite formulation in Greece, at the hands of Pythagoras and Plato. According to this philosophy, the whole universe is based on number. Everything, it was thought, resolved into multiple series; and every relationship could be expressed in numerical proportion. The next step was to formulate an ideal law of proportion, and

following the principle of economy (*entia non sunt multi-plicanda*) the formulation of such a proportion expressed in the simplest terms was:

$$\frac{a + b}{a} = \frac{a}{b}$$

or, expressed verbally: to divide any definite dimension so that the whole is to a greater part of it as that greater part is to the lesser part.

This proportion was called the "divine proportion" (or, in its linear aspect, the Golden Section, or the Golden Cut), and from the time of Pythagoras (who perhaps only derived it from remoter Egyptian philosophers) it plays an enormous part in the history, not only of science, but also of art.

For it was early discovered, perhaps by Pythagoras's Egyptian predecessors, that this ideal proportion, so logically and rationally determined by pure thought, plays a preponderant part in the morphology of the natural world, both organic and inorganic. The forms of crystals and shells, of plants and flowers, and of the human body itself, appeared in an almost miraculous way to resolve into this equation or proportion. I cannot follow here all the consequences of this discovery in the history of human thought; the reader who is not already familiar with them will find full information in the books noted below.* But in the sphere of art it led to the adoption of this proportion, in

* The literature of what may be called the morphology of art is considerable. The best up-to-date summary may be gained from two works by Matila C. Ghyka: *Esthétique des proportions dans la nature et dans les arts* (Paris, 1927) and *Le Nombre d'or: rites et rythmes pythagoriciens dans le développement de la civilisation occidentale* (Paris, 1931). Among works available in English, the following may be consulted: *Dynamic Symmetry*, by Jay Hambidge (new ed., Yale University Press, 1958); *The Curves of Life*, by Sir Theodore Cook (London, 1914); *Ad Quadratum*, by F. M. Lund (2 vols., London, 1921). These works contain abundant references to the earlier literature of the subject. For a more fundamental work, investigating the laws under which organic life evolves, see *On Growth and Form*, by Sir D'Arcy Wentworth Thompson (new ed., Cambridge, 1952).

all its possible extensions and combinations, as a canon of composition and form. It was used to a very considerable extent in Greek architecture, sculpture, and pottery, and in Roman art; the whole of the Renaissance was fascinated by it, but so indeed was the Gothic period. It is still used, even by the most modern artists and architects. It has all the prestige of a law of nature, with more than a suggestion of mystery and magic.

Such a law (it is not the only one in use, but I do not wish to complicate the present discussion) is the typical basis of a conscious or rational canon of form in art. A subtle variation of it should be noted, which Ruskin formulated in a phrase:

All beautiful lines are drawn under mathematical laws organically transgressed.

It is felt, or imagined, that a work of art which slavishly follows a law of proportion such as the Golden Section will be dry or dead. It is observed that in the best Greek buildings—the Parthenon, for example—there are slight deviations from the true proportions. Hence the conclusion is reached, that if we are conscious of a law of proportion, and then slightly deviate from it, to avoid its precision, we shall produce a more beautiful effect. The same argument is used of the metrical irregularities of verse, where it certainly has some application. Probably the cause of the pleasure we experience by the sense of such deviations is ethical rather than aesthetic—an affirmation of our free-dom of will, an escape from determinism in art. But in any case, the matter is so subtle that I do not think it will ever submit to analysis.

Apart from such rational canons of form, and limited deviations therefrom, there undoubtedly exist forms in art and in nature which cannot be resolved into number and

proportion. Since they are not rationally apprehended, we might perhaps venture to say that they are intuitively apprehended. I use the word "intuition" with due caution,* and without any special psychological intention—merely as a convenient term for a process of direct perception which is a perfectly normal experience. Now it is possible that we may be intuitively aware of harmonic proportions; we do not need to be philosophers or geometricians to perceive that a form which has the divine proportion is a beautiful form. Perhaps we derive from our own physical constitution, from the apparatus of breathing, of focusing, from the symmetry of our bodies and the symmetry of nature, a generalized sense of harmonic form which we intuitively apply when we "apprehend" a work of art. Artists, undoubtedly, sometimes work to the Golden Section by instinct, and not deliberately. But that is only the synthetic aspect of the process we have already analyzed. My present contention is that there exists a still further type of form—form projected from, or selected by, our unconscious faculties.

For the purpose of this brief explanation I adopt the terms of the Freudian theory, according to which there are three levels of mental activity—the conscious level of thought; the subliminal or "preconscious" level of daydreams and dreams, normally below the level of consciousness, but accessible in sleep and hypnosis; and thirdly, the Id, or completely suppressed level of unconscious psychic activity. It seems to me possible that, apart from the forms which appeal to our conscious minds for

* I have tried to reach a satisfactory definition of it for general critical purposes in an essay on "Descartes" (*Collected Essays in Literary Criticism*, pp. 183–95). For a more detailed treatment of the unconscious origin of symbolic form in art, see my contribution ("The Dynamics of Art") to the *Eranos Jahrbuch*, Vol. XXI (1952), Rhein Verlag, Zurich, 1953.

the reasons already discussed, there may be forms, specific for each level, which appeal to the preconscious and unconscious levels of the psyche. On the preconscious level such forms would probably have a symbolic appeal—according to Freud, always of a sexual import; but on the unconscious level such forms might be much less specific. Conceivably we shall never have any precise knowledge of the matter, but buried in this limbo may be the impresses of prenatal experiences, birth traumas, and even, some psychologists would suggest, racial experiences. For reasons which we cannot possibly determine, these experiences or psychic states might give us an unconscious predilection for certain shapes or forms. For example: almost identical laws of proportion can determine, by very different applications, the proportions of a Greek temple and a Gothic cathedral; but what has determined the totally different spatial conception of the interiors of two such buildings? Climate and function will afford a superficial explanation; but beyond such material determinism is a vast complex of psychological factors inherent in the social consciousness of the races that built such buildings.

I do not raise these problems to present a solution; I merely wish to suggest that the question of form in art—even in industrial art—is not a simple one. It cannot be solved by a rule of thumb. If the Golden Section or some other canon of proportion were made compulsory for all industrial design, I have no doubt that the whole standard of production would be improved; but only at the cost of a profounder and more essential vitality.

Let us consider two particular objects—a Chinese porcelain vase of the Sung period and a typical Greek vase of the sixth century B.C. (Figures 9 and 10). Both are without naturalistic decoration and both depend for their

appeal on their form alone. The Greek vase is based on exact measurements, and its proportions are regular—that is to say, they are based on certain laws of harmonic proportion, such as the Golden Section. The Chinese vase is also based on exact measurements (a perfect circle with tangential lines and minor proportions determined by consequential measurements) but there is no insistence on its geometry.* The Greek vase has been trimmed to a perfectly smooth and precise outline, symmetrical about its axis. Every trace of the potter's hand has been carefully removed. The Chinese vase, on the other hand, still shows traces of the ridges left by the potter's fingers, and the glaze has been allowed to run irregularly down the surface, and finish in an uneven surf above the foot. Admittedly any judgment between the two vases must be subjective, but I do not think there is any doubt that the average sensitive person, the "man of taste," would find the Chinese vase superior as a work of art. And that, I believe, is because its form has an appeal which cannot be analyzed, which is not intellectual, but intuitive or unconscious.

I think we may conclude, therefore, that this intuitive element in a work of art is of considerable value, even in the useful arts, and if this is a quality that cannot survive in the machine age, then, *unless there are compensatory qualities*, we are doomed to an art of limited aesthetic appeal.

* Mr. Russell Spruce has supplied me with a geometrical analysis of this vase which accounts for all its proportions and curves.

the function of decoration

Before passing on to the possibilities of compensatory qualities in machine art I would like to refer to the function of decoration.

Again there is some confusion of terminology. A form in itself may be "decorative," but that usually implies the relation of an object to its setting. We *decorate* a room when we paint the woodwork and paper the walls, but that sense merely implies that we give it color. When we decorate a work of art, an *objet d'art*, as it is then usually called, we add to its form an extra thing which is known as *ornament*. Ornament can be added to almost any work of art—we add carved capitals and friezes to architecture, color and pictures to pottery; even the cabinet picture is not complete without its ornamental frame. All such ornament is *applied* to the work of art, and this is where the word *applied* has its original and proper sense. But by one of those monstrous misapplications of words which can confuse thought for centuries, the epithet was taken from ornament and given to art. Applied ornament became applied art, and all the commissions of inquiry, all the museums and schools of art in the country, have labored under this confusion for a century or more. The necessity of ornament is psychological. There exists in man a certain feeling which has been called *horror vacui*, an incapacity to tolerate an empty space. This feeling is strongest in certain savage races, and in decadent periods of civilization. It may be an ineradicable feeling; it is probably the same instinct that causes

certain people to scribble on lavatory walls, others to scribble on their blotting pads. A plain empty surface seems an irresistible attraction to the most controlled of men; it is the delight of all uncontrolled children. While I think that a little discipline would be a very good thing, I by no means wish to urge the total suppression of the instinct to fill blank spaces. I deal with the question more fully in Part 3. At present, all I wish to insist on is that the instinct is not essentially aesthetic. All ornament should be treated as suspect. I feel that a really civilized person would as soon tattoo his body as cover the form of a good work of art with meaningless ornament. The only real justification for ornament is that it should in some way emphasize form. I avoid the customary word "enhance," because if form is adequate, it cannot be enhanced. Legitimate ornament I conceive as something like mascara and lipstick—something applied with discretion to make more precise the outlines of an already existing beauty.

Since both our educationists and manufacturers have for so long been blind to the formal elements in art, they have tended to regard ornament as the only essential element, and their failure has been largely due to this misguided attempt to contort and twist and otherwise deform the naturally austere and precise forms of manufactured articles into the types of ornament they mistake for art.

Wedgwood

It would help us at this point to consider two historical attempts to solve our problem. One comes right at the beginning of the industrial age, and is so interesting and

instructive that it would merit a separate and exhaustive examination. All the problems that confront us now were obvious to Josiah Wedgwood, one of the greatest of industrial geniuses, a man who in his own lifetime converted a peasant craft into an industrial manufacture, a man who, in whatever sphere he had applied his gifts for organization and rationalization, would have effected a revolution. When the German poet and philosopher Novalis wanted an apt comparison to bring out the essential character of Goethe he thought of Wedgwood. Goethe, he said, is the completely practical poet. "His works are like the Englishman's wares—extremely simple, neat, convenient, and durable. He has done for German literature what Wedgwood did for English art. He has, like the Englishman, by virtue of his intelligence, acquired a fine taste, which taste is economic in nature. Both men go together very well, and have a near affinity in the chemical sense."

How illuminating this comparison is for our understanding of Goethe is beside the point, but it gives the real clue to an appreciation of Wedgwood's genius. His name has a quite peculiar significance, not only as a great potter, but also as a leading figure in the development of taste. It was largely due to Wedgwood's activities that the cult of a few dilettanti was taken up and propagated until it became the commercial aspect of that phase in the history of art known variously as the Classical Revival, Neoclassicism, the Empire Style.

Josiah Wedgwood was born at Burslem, in Staffordshire, about July 1, 1730. He belonged to a family which had followed the craft of pottery for many generations, but so far pottery had been little more than a peasant industry. The productions of the primitive kilns of Staffordshire, though possessing simplicity and vigor and a kind of native

raciness—qualities which we have learned to respect—had no pretensions to dignity and conferred no prestige on their makers. But toward the end of the seventeenth century two Dutchmen, the brothers Elers, had introduced improved methods into Staffordshire, and their ideas had been taken up by a local potter, Thomas Whieldon. It was with Whieldon that Wedgwood eventually became associated. From Whieldon, whom he joined at Little Fenton in 1754, Wedgwood no doubt learned all that the local tradition of pottery could teach him, but at the end of his five years' agreement he returned to Burslem, determined to strike out on his own.

A potter, no less than a poet, is born, not made; but though Wedgwood could doubtless practice all the processes of his craft with ability and ease, it would be a mistake to consider him as anything in the nature of an inspired artist. Novalis's distinction implies that whereas taste can be formed by application and understanding, art is the product of inspiration or intuition. Wedgwood was primarily what we should now call a great rationalizer of industry; he was bent on eliminating waste, on improving processes, on creating a demand where it had not previously existed. Fine porcelain in his day was a rarity imported from China or the Continent, a luxury for the rich. Factories had sprung up in England (at Chelsea, Bow, etc.) to compete with these imported luxuries, but their existence was precarious and their products were regarded as inferior. Wedgwood's aim was not to compete with the foreign factories on their own ground, but to provide an alternative. In this he succeeded beyond his wildest dreams.

Merely as a technician Wedgwood deserves his fame. He built bigger and better kilns; he improved the wheel

and introduced the turning lathe which enabled the potter to give finish and precision to his wares; he investigated and vastly improved the chemical constituents of clays and glazes; he discovered new types of wares, such as "black basaltes" and "jasper"; he invented the pyrometer for measuring the heat of the furnaces, thereby first making possible a perfect control of the firing. For this he was made a Fellow of the Royal Society. His practical activities extended beyond his own industry. He led his fellow industrialists in their demand for turnpike roads and canals. As his export trade grew he had to solve difficult problems of packing and transport. He had to arrange an elaborate system of travelers and agencies. At every turn his practical genius triumphed. When he died he was worth half a million pounds—the equivalent, in modern currency, of the fortunes of our great industrial magnates.

All that material grandeur would have passed away and left a name in nothing but the economic history of our country, had not Wedgwood had the wit to discover that "art pays." His intelligence was wide enough to admit a considerable respect for the humanities. While cultivating these interests during a convalescence, he fell in with the intellectual society led by Dr. Priestley. He formed a friendship with Thomas Bentley, a Liverpool merchant, described by Priestley as "a man of excellent taste, improved understanding, and good disposition." In Bentley, Wedgwood saw his ideal partner—the man who would bring culture into association with his industry and direct his energy into the channels of correct taste. The partnership, formally entered into in 1768, prospered exceedingly, and lasted until Bentley's death in 1780. The letters they exchanged during the period have been published, and are a complete revelation of Wedgwood's mentality, and of the

spirit that was to carry through the Industrial Revolution.

Under Bentley's guidance Wedgwood was drawn into the circle of Sir William Hamilton, who was then publishing his illustrated portfolios of Greek and Etruscan antiquities. By his activities the British Minister at Naples had set a mode, and Wedgwood was quick to seize on its significance for him. Once before in the history of art, pottery had been the medium of a nation's highest artistic genius. A Grecian urn was a symbol for all the grace and serenity of the ancient world. Wedgwood determined that pottery should again rise to those heights. The best artists in the land, John Flaxman at their head, were commissioned to copy ancient prototypes or adapt them to modern uses. In a sense they succeeded all too well. A classical mode was imposed upon the whole of decorative art: it might be said that a style of architecture and furniture had to be invented to accommodate the imperious products of Wedgwood's activity. The movement conquered Europe, and dominated a generation. Today we can see that it was only a surface movement, like all culture determined by intelligence rather than sensibility. Wedgwood's ornamental wares have in their turn become antiquities, objects for the curious and the contented. His useful wares, in which his true genius was expressed, are still with us, for we can hardly eat from a plate or drink from a cup that does not bear the impress of his practical genius.

The fate of Wedgwood's pottery is thus very significant for our inquiry. The useful wares which have survived—not as "works of art," but as the prototypes of the best useful wares still being made by Wedgwood's firm, and by countless imitators all over the world—these wares were the product of the local pottery tradition, selected and refined by the practical genius of Wedgwood, himself a

trained potter. In *English Pottery*, a book by Mr. Bernard Rackham and myself, published in 1924, we observed of these useful wares that "Wedgwood was the first potter to think out forms which should be thoroughly well suited to their purpose, and at the same time capable of duplication with precision in unlimited quantities for distribution on the vast scale now imposed by the great extension of trade which he helped so much to foster. . . . The shapes are, as a rule, thoroughly practical, and many, such as the round-bellied jug with short wide neck and curved lip, good for pouring and easy to keep clean, have remained standard shapes to the present day. Lids fit well, spouts do their work without spilling, bases give safety from over-turning; everywhere there is efficiency and economy of means." In these words we defined a machine *art* in its first phase, and with all its essential features. We then went on to contrast the "ornamental" wares designed for Wedgwood, not by practicing potters, but by independent artists (painters and sculptors) like Flaxman and Pacetti. After noting that such wares mark the beginning of a dualism in English pottery which until then had never existed, we observed:

"From the point of view of the potter it was a misfortune for Wedgwood that the pottery from which he chiefly drew his inspiration for his innovations—whatever virtues it may possess in exquisite beauty of draughtsmanship and grace-fulness of shape—was not good pottery. In ceramic quali-ties, Greek vases of the 'best' period stand far behind the ancient wares of Egypt, Persia, and the Far East, and are inferior even to the unpretentious pottery made far and wide by aborigines in the provinces of the Roman Empire. Their shapes are copied from, or intended to emulate, metal-work; nor do they depend for decoration on the

plastic qualities of clay. All is left to the brush—never, it is true, more skilfully wielded by ceramic painters than by the best artists of Athens, to the enormous advantage of our studies of ancient Greek life and literature, but with great loss to the value of Greek vases as pottery. Nor was it by vases alone that the eager mind of Wedgwood was stimulated; he was no less interested in the statues, altars, sarcophagi, and reliefs in sculptured stone that the spade of the excavator and the burin of the engraver were bringing for the first time to the knowledge of the world at large."

The source of the dualism of the "fine" and the utilitarian arts is therefore easy to trace in the limited sphere of pottery. For on the one hand we have the potter relying on his own knowledge of the craft and designing for use; on the other hand we have the potter relying for his design on the outside artist, who is not concerned to design for use so much as for ornament—as an exhibition, that is to say, of his artistic skill and "taste."

Morris

The case of William Morris, a century later, is equally instructive. He differed from Wedgwood in not being born to a trade. Wedgwood's reforms sprang from an internal necessity of the time and the craft. Morris was external, dilettante. The son of wealthy parents, he was educated at Marlborough and Oxford, remote from scenes of industry such as those in which Wedgwood had his upbringing. During his first year at Oxford, *The Stones of Venice* was

published, and that event (for it was more than a book) determined the rest of Morris's life. When we have traced the workings of Ruskin's doctrines in the robuster mind and frame of Morris, we have explained the general course of his life; any differences are temperamental, not intellectual. But though Ruskin did sometimes apply his doctrines in an eccentric and wasteful fashion, the virtue of Morris is that with all his enthusiasm, and in spite of his financial incapacity, he was essentially a practical genius, carrying theory into action, embodying beauty in things of use, giving organization to opinion.

It is customary to consider Morris in this threefold aspect as poet, craftsman, and socialist. In this way we break down the fundamental unity of the man. Perhaps he was too normal in his psychology to possess the particular concentration of faculties and sensibilities that makes a great artist. His purpose was rather to show how art entered into the life of every man, and entered in no merely passive or receptive way. The best joy, he felt, was the joy of making things, and knowing that you made them well. In this spirit a man should be able to make all that he needs, not only his house and his furniture, his tools and utensils, his tapestries and pictures, but even his music and song; and he believed that the necessary faculties exist in every human being, and need only a right ordering of society to educate them and make them adequate.

With such ideals he was inevitably led to oppose the development of machinery, and the ugliness and degradation which he associated with that development. Such unreality as we now connect with the name and the works of Morris is due to the false objective he thus set up. The machine has triumphed, and only now are we beginning to accept that inevitable fact, and to work out an aesthetic

and social philosophy based on that fact. What Morris actually achieved, in the design of fabrics, wallpapers, and above all in typography and books, did have its influence on machine-made products; it was a good influence, but essentially a superficial one. It was mainly in the sphere of applied ornament and decoration, and did not touch the more fundamental problems of form.

Toward the end of his life, when he had been brought so closely into contact with the realities of the industrial situation through his socialistic activities, Morris had to modify his attitude toward the machine. "Those almost miraculous machines," he wrote in *Art and Socialism*, "which if orderly forethought had dealt with them might even now be speedily extinguishing all irksome and unintelligent labour, leaving us free to raise the standard of skill of hand and energy of mind in our workmen, and to produce afresh that loveliness and order which only the hand of man guided by his own soul can produce; what have they done for us now?" But that admission is far from being a reconciliation. Machines are still conceived as nothing better than scavengers and coal-heavers. They are not yet recognized as tools of a precision and power never dreamed of in the days of handicraft (the hand which is powerless without a tool), to be used intelligently for the production of works of art.

It will be seen that Morris's attitude was the inverse of Wedgwood's. Wedgwood was the industrialist who thought of art as something external which he could import and use; Morris was the artist who thought of industry as something inconsistent with art, and which must therefore be reformed or abolished. Of the two attitudes, Wedgwood's is much the simpler—indeed, it is naïve. Morris's attitude is complicated by ethical considerations which most of us

find sympathetic. Sometimes, in his more resigned moods, his speculations are not so remote from possibility. In an essay on *The Aims of Art,* first published in 1887, he wrote:

"I suppose that this is what is likely to happen; that machinery will go on developing, with the purpose of saving men labour, till the mass of the people attain real leisure enough to be able to appreciate the pleasure of life; till, in fact, they have attained such mastery over Nature that they no longer fear starvation as a penalty for not working more than enough. When they get to that point they will doubtless turn themselves and begin to find out what it is that they really want to do. They would soon find out that the less work they did (the less work unaccompanied by art, I mean), the more desirable a dwelling-place the earth would be; they would accordingly do less and less work, till the mood of energy, of which I began by speaking, urged them on afresh: but by that time Nature, relieved by the relaxation of man's work, would be recovering her ancient beauty, and be teaching men the old story of art. And as the Artificial Famine, caused by men working for the profit of a master, and which we now look upon as a matter of course, would have long disappeared, they would be free to do as they chose, and they would set aside their machines in all cases where the work seemed pleasant or desirable for handiwork; till in all the crafts where production of beauty was required, the most direct communication between a man's hand and his brain would be sought for. And there would be many occupations also, as the processes of agriculture, in which the voluntary exercise of energy would be thought so delightful, that people would not dream of handing over its pleasure to the jaws of a machine."

The machine is still a moloch, and the fundamental

heresy of Morris's position peeps out of a phrase like "in all the crafts where production of beauty was required" (as though beauty were the special concern of a limited number of crafts, and not the universal aim of all); but apart from such considerations, the passage needs only the application of our distinction between humanistic and abstract art to make it the outline of a possible ideal. If the necessary adjustments can be made in the monetary system so that the capacity to consume bears a relation of approximate equality to the power of production; if the age of plenty, already potential, can be realized in fact: then the increase in leisure will undoubtedly lead to a development of man's innate desire to create an art expressive of his individuality—humanistic art, as we have called it. Such art will bear to abstract machine art the kind of relation that a landscape painting bears to the architecture of a functional building; the relation of an arbitrary phenomenon to a logical or necessary one. But if we are not to relapse into the nineteenth-century muddle again, there will be no confusion between the two types of art.

Though I believe that Morris would now accept such a distinction, and would in these days be reconciled to the inevitability of machinery, there are still to be found remote disciples of his ready to fight for the lost cause. I do not mean an enlightened critic of the industrial system such as Eric Gill: there are extreme reactionaries for whom even Gill was too compromising, as will be evident from a paragraph which I have extracted from a review of one of his books, *Beauty Looks After Herself*:

"In all this we can see industrialism working itself out to its logical and anarchic conclusion. Architecture is being thrust out of society, and as architecture is the mother of the arts, its dependants will be thrust out with it, when the

cult of ugliness will be supreme, for experience proves that none of the arts can stand up against machinery and mass production. The crafts were the first to suffer. Now the turn of the fine arts has come. The latter are not attacked so much by machinery direct as were the crafts, but they wither in the new social atmosphere that has come into existence with the increasing mechanisation of life and industry. A people whose occupations are mechanical, whose leisure is spent in motor cars and cinemas, whose ideal is speed and whose god is money cannot discover points of contact with the arts whose existence presupposes life lived in a more leisurely and contemplative fashion. They belong to different worlds and no communication is finally possible between them. Hence our dilemma. It is no use attempting to save the arts as Mr. Gill and the modernists would have us do by advising architects, artists and craftsmen to throw in their lot with industrialism, for that can only make the destruction absolute. Art has to do with the ends of life, while industrialism is concerned with means. And it is impossible for ends to serve means, which is what would have to happen for the arts to derive their inspiration from industrialism." *

The passage I have quoted from Morris should have reassured his fanatic disciple; industrialism promises a life spent in a more leisurely and contemplative fashion, a life in which art can once more be concerned with ends. But the main fallacy underlying this argument is the usual one: the failure to distinguish between the abstract, nonfigurative arts which find perfect embodiment in "the means of life," and the humanistic or fine arts which express "the

* Arthur J. Penty, *The Criterion*, Vol. XIII (1934), p. 368. For a more recent and even more extreme expression of this point of view, see *The Failure of Technology: Perfection without Purpose*, by Friedrich Georg Juenger (Hinsdale, Illinois: Regnery, 1956.)

ends of life." That distinction once made, the agonizing dilemma raised by Gill's critic disappears.

the problem restated

The problem, it will now be clear, is not the simple one: can the machine produce satisfactory works of art; that is to say, in the sense of Ruskin and Morris, can the machine continue the tradition of ornament characteristic of European art since the Renaissance? If that were the only problem, it has long since been answered by practical demonstration. The machine product has no need of such ornament, and even if it had any need of it, could not produce it.

The machine has rejected ornament; and the machine has everywhere established itself. We are irrevocably committed to a machine age—that surely is clear enough now, nearly a century after the publication of *The Stones of Venice*. The cause of Ruskin and Morris may have been a good cause, but it is now a lost cause.

Leaving on one side the economic and ethical problems involved (such problems as the displacement of human labor and the use of enforced leisure), we are left with the only problem for present discussion: CAN THE MACHINE PRODUCE A WORK OF ART? One might put the question less crudely; one might ask, for example, whether the machine can satisfy the aesthetic impulses the satisfaction of which we believe to be a biological necessity. Or one might ask whether man can find in machine production sufficient exercise for his constructive faculties, for that structural

science which is one element in all art. Or from still another angle, one might ask what is the function of the artist in the machine age? But the simple question: *Can the machine produce a work of art?* includes all these subsidiary and related questions.

Our discussion of the general nature of art has left us with two distinct types:

> *humanistic art,* which is concerned with the expression in plastic form of human ideals or emotions; and

> *abstract art,* or nonfigurative art, which has no concern beyond making objects whose plastic form appeals to the aesthetic sensibility.

We found further that objects of abstract art might appeal to our sensibility for either physical or rational reasons, because they obeyed certain rules of symmetry or proportion; or that they might appeal—perhaps not only to our sensibility in the accepted sense of the word, but also to some obscurer unconscious faculty, because of a formal quality which is beyond analysis.

These distinctions being made, my contention is then that the utilitarian arts—that is to say, objects designed primarily for use—appeal to the aesthetic sensibility *as abstract art;* and we concluded that this appeal might be intuitional as well as rational; that the form of objects in use is not simply a question of harmony and proportion in the geometric sense, but may be created and appreciated by intuitional modes of apprehension.

Since what I have called rational abstraction in art is measurable, and resolves into numerical laws, it is obvious that the machine, which works to adjustment and measure,

can produce such works with unfailing and unrivaled precision. Such beauty as we admire in Greek vases, and in the undecorated forms of Mediterranean art generally, can undoubtedly be produced by machinery, and in materials more suitable than any available to Classical or Renaissance artists. All the objects of machine manufacture illustrated in this book demonstrate the fact. Such objects can satisfy all the canons of beauty which have a basis in numerical proportion. The artist is the individual (generally called the *designer*) who decides the proportions to which the machine works. His problem is to adapt the laws of symmetry and proportion to the functional form of the object that is being made.

Such a designer differs only in degree (in the nature of his materials and the simplicity of his object) from the designer of a motorcar, a building, or a bridge. The most typical designer of the machine age is the constructive engineer. In so far as he reconciles his functional aims with ideals of symmetry and proportion, he is an abstract artist.

But we have concluded that the highest kinds of abstract art are not rational. The highest kinds of abstract art cannot be worked out by rule and measure. They depend on an intuitional apprehension of form. We are therefore finally reduced to asking ourselves whether machine methods are capable of producing these subtler forms.

standardization

Naturally such forms will be standardized and uniform. That does not seem to me to be an objection, if they conform to all other aesthetic requirements. The quality of

uniqueness must obviously be sacrificed in the machine age. But what is the worth of such a quality? It is certainly not an aesthetic value. The sense of uniqueness—is it not rather a reflection of the possessive impulse, an ethically unworthy impulse typical of a bygone individualistic phase of civilization?

If there were any danger of a shortage of machines, so that all diversity disappeared from daily life, there would be some cause for alarm. But actually machines multiply and change rapidly, and their products are of far greater diversity than those produced by handicraft.

Let us dismiss, then, any fears we may have of standardization. We must still ask whether the standardized object can possess or express intuitive form.

formal values in machine art

And to that question we can answer: it already does. Whenever the final product of the machine is designed or determined by anyone sensitive to formal values, that product can and does become an abstract work of art in the subtler sense of the term. It is only the general confusion between art and ornament, and the general inability to see the distinction between humanistic and abstract art, and the further difference between rational abstraction and intuitional abstraction, that prevents us regarding many of the existing products of the machine age as works of art, and further prevents us from conceiving the endless possibilities inherent in machine art.

The existence of intuitional form in products of the ma-

chine age can be demonstrated only by actual examples, and then the demonstration cannot, by the nature of the thing, be rationalized. All I can do is to refer the reader to the plates illustrating various examples of modern architecture, furniture, utensils and vessels, all types of machine production, and ask him to admit their aesthetic appeal; I could then show that the proportions of such objects do not obey any consciously applied laws of proportion; that they are, in fact, intuitional forms, or perhaps functional forms that have acquired incidentally an intuitive appeal.

Against the hundreds of such examples which might be quoted, there are thousands of machine products which have no aesthetic appeal at all—which are purely functional and aesthetically meaningless. Such a distinction is only too obvious, and our whole problem is to investigate the cause of the distinction.

Some functional objects, it will be said, cannot by any conceivable chance be made beautiful. I will admit that it is sometimes difficult to see the possibility, but a little observation will soon show that the most unexpected objects can acquire an abstract kind of beauty. The motorcar is the obvious example, but a better example still is the wireless receiving set, which in a short period of five or ten years made an enormous progress toward good design. Roger Fry once doubted whether a typewriter could ever be beautiful, but in recent years new designs for typewriters have been evolved (Figure 104) which are infinitely better in shape and appearance than previous models, and though one might still hesitate to call them works of art, they are certainly progressing in that direction. But to return to our investigation: I believe it would be found that wherever good forms emerge from factories, a designer with aesthetic sensibility is always present and responsible.

Such a designer will not always be called by that name, nor even be himself aware that he has aesthetic sensibility; but we are speaking of realities, not of conventional categories. In the case of architects like Gropius and Mendelssohn, the fact is recognized; these men are artists, in the fullest sense of the term—not humanistic artists, of course, but practical and abstract artists. In the same way the designer of steel or plywood furniture, as obviously of machine-made pottery and glass, is a designer of abstract forms, and, according to his sensibility and genius, designs greater or lesser works of art.

Our real need is therefore a fuller recognition of the abstract artist in industry. The modern movement in painting and sculpture has produced abstract artists in considerable numbers. Some of these have already turned their energies toward industrial design, but the majority of them are still producing pictures (abstract designs on canvas) which they offer for sale in rivalry with the traditional products of humanistic art. So long as it is difficult to satisfy one's need for abstract art in machine-made objects—that is to say, in the objects of everyday use—such art fulfills a very important function; it keeps untainted, so to speak, the formal essence of all art. Personally I feel that for many years to come there will be a school of abstract painting; a new category of painting—virtually a new plastic art—has developed out of cubism, and this art, as practiced by painters like Mondrian and Ben Nicholson, and by sculptors like Pevsner and Naum Gabo, is very valuable as a "pure" art controlling the development of formal art in general. It will occupy, in the future, a relationship to industrial design very similar to the relationship pure mathematics bears to the practical sciences. Probably such artists will be as rare and remote as pure mathema-

ticians, but they will have an essential place in the aesthetic
structure of the machine age.

the solution proposed

We now, I hope, begin to see the solution of the problem
we are concerned with. We must recognize the abstract
nature of the essential element in art, and, as a conse-
quence, we must recognize that design is a function of the
abstract artist. The abstract artist (who may often be iden-
tical with the engineer or the technician) must be given a
place in all industries in which he is not already estab-
lished, and his decision on all questions of design must be
final. That is to say, the designers should not be required
merely to produce a number of sketches on paper which
will then be left to the mercy of factory managers and
salesmen to adapt to the imaginary demands of the pub-
lic; the artist must design in the actual materials of the fac-
tory, and in the full stream of the process of production.
His power must be absolute in all matters of design, and,
within the limits of functional efficiency, the factory must
adapt itself to the artist, not the artist to the factory.

Naturally such a reorganization could not come about
in the present industrial system. Though the present-day
industrialist is aware of the commercial value of good de-
sign, no spontaneous improvement is likely to come about
because now, as a hundred years ago when Mr. Ewart's
committee was appointed for the same purpose, industry
is run for the most part by people who have no understand-
ing of the meaning of art, and no inclination to resign any

of their functions to the artist. They will continue to defend their inferior designs against superior designs from abroad by higher and higher tariffs, and so long as the industrialist can rely on this protection, the consumer will have to be satisfied with clumsy cutlery, crude textiles, ugly furniture and uglier houses. Only the rich will be able to afford the decency and simplicity of foreign products which come from countries where a solution of the problem has already been effected.

As I try to show in Part 4, the problem is primarily educational. We have to create a new consciousness of aesthetic form. We must put an end to the inculcation of false and superannuated ideals of beauty—ideals which are largely a superficial "taste," a cultural veneer inherited from other ages, when the processes of production were entirely different. Nothing less than a complete revision of our educational system, in so far as it is concerned with the question of art and technique, will suffice to bring about the necessary change. The possibilities of such a change of attitude, and its vitalizing effect on the design of a whole country, have been demonstrated by the Bauhaus experiment carried out under the direction of the German architect Walter Gropius. In that experiment we have had a practical demonstration of methods we can at once adopt. Let me quote a description of those methods written by Dr. Gropius himself: "The transformation from manual to machine production so preoccupied humanity for a century that instead of pressing forward to tackle the real problems of design, men were long content with borrowed styles and conventional decorations. This state of affairs is over at last. A new conception of building, based on realities, has developed; and with it has come a new changed perception of space. . . .

"The Bauhaus accepted the machine as the essentially modern vehicle of form, and sought to come to terms with it. Its workshops were really laboratories in which practical designs for present-day goods were conscientiously worked out as models for mass production, and were continually being improved on. This dominant aim of creating type-forms to meet every commercial, technical, and aesthetic requirement necessitated a picked body of men of all-round culture who were thoroughly experienced in the practical and mechanical, as well as the theoretical, scientific, and formal aspects of design, and were well versed in the laws on which these are based. The constructors of these models had also to be fully acquainted with factory methods of mechanical mass-production, which are radically different from those of handicraft, although the various parts of the prototypes they evolved had naturally to be made by hand. It is from the individual peculiarities of every type of machine that the new, but still individual 'genuineness' and 'beauty' of its products are derived; whereas illogical machine imitation of hand-made goods infallibly bears the stamp of a make-shift substitute. The Bauhaus represented the school of thought which believes that the difference between industry and handicraft is far less a difference due to the nature of the tools employed than of the effect of subdivision of labour in the former and one-man control from start to finish in the latter. Handicrafts and industry must, however, be understood as opposites perpetually approaching each other. Handicrafts are now changing their traditional nature. In future their field will be in research work for industrial production and in speculative experiments in laboratory-workshops where the preparatory work of evolving and perfecting new type-forms will be done.

". . . Our guiding principle was that artistic design is neither an intellectual nor a material affair, but simply an integral part of the very stuff of life. Further, that the revolution in artistic mentality has brought in its train that new elementary knowledge which is implied in the new conception of design, in the same way that the technical transformation of industry has provided new tools for its realisation. Our object was to permeate both types of mind; to liberate the creative artist from his other-worldliness and reintegrate him into the workaday world of realities; and at the same time to broaden and humanise the rigid, almost exclusively material mind of the business man. Our governing conception of the basic unity of all design in its relation to life, which informed all our work, was therefore in diametrical opposition to that of 'art for art's sake,' and the even more dangerous philosophy it sprang from: business as an end in itself." *

I have no other desire in this book than to support and propagate the ideals thus expressed by Dr. Gropius: ideals which are not restricted to the written word, but which have been translated into action, made objective in the industrial world, and there demonstrated their truth and practicability. Essentially it is a policy based on a rational conception of aesthetic values. Our need is the wider recognition of art as a biological function, and a constructive planning of our modes of living which takes full cognizance of this function. In every practical activity the artist is necessary, to give form to material. An artist must plan the distribution of cities within a region; an artist must plan the distribution of buildings within a city; an artist must plan the houses themselves, the halls and factories

* From a paper read to the Design and Industries Association, reprinted in the *Journal of the Royal Institute of British Architects,* May 19, 1934.

and all that makes up the city; an artist must plan the interiors of such buildings—the shapes of the rooms and their lighting and color; an artist must plan the furniture of those rooms, down to the smallest detail, the knives and forks, the cups and saucers and the door handles. And at every stage we need the abstract artist, the artist who orders materials till they combine the highest degree of practical economy with the greatest measure of spiritual freedom. Such artists are "abstract" only in the sense that they combine human needs with organic laws; for nature herself is abstract, essentially mathematical: and our human needs simply acquire the conditions of their greatest freedom when they conform to that discipline "whose golden surveying reed marks out and measures every quarter and circuit of New Jerusalem" (Milton).

PART 2

FORM

Of how it is that the soul informs the body, physical science teaches me nothing; and that living matter influences and is influenced by mind is a mystery without a clue. Consciousness is not explained to my comprehension by all the nerve-paths and neurones of the physiologist; nor do I ask of physics how goodness shines in one man's face, and evil betrays itself in another. But of the construction and growth and working of the body, as of all else that is of the earth earthy, physical science is, in my humble opinion, our only teacher and guide.—D'ARCY WENTWORTH THOMPSON: *On Growth and Form*

the general aspect

In Part 1 we considered Form from a theoretical point of view, and decided that while its appeal was always of an abstract nature, that appeal could be either *rational* or *intuitional*. We were then considering form apart from all incidental characteristics. But form must be embodied in material, and in the kind of art with which this book is dealing, that material form has also a practical function or purpose. Pure abstract art does exist, as I have shown, and though the aesthetic appeal in useful objects is primarily of an abstract nature, the purity of that abstraction is modified by these further characteristics—material and purpose.

material

Materials are either inorganic or organic. They may also be "synthetic," and it is possible that separate principles will have to be worked out for some of the new materials which are now being produced on an industrial scale. But in so far as these new materials are plastic (and "plastics" is indeed the popular name for them), they are materials which are worked in a mold, and the general principles which are laid down for the use of this process for inorganic materials like pottery and glass apply to these new synthetic materials; the danger seems to be that the great freedom of working which the new materials permit will lead to the imitation of inappropriate forms—forms which have arisen out of the essential qualities of wholly different materials. There is no reason, for example, why plastics should imitate the blown forms of glass or the jointed construction of woodwork. It is essentially a moldable material.

Inorganic materials consist of various rocks and metals dug out of the earth, and generally refined or in other ways made suitable for working. Such materials and products give rise to the following principal divisions of industrial art:

Pottery, Glass, Metalwork. The logical French mind sometimes classifies these arts as *les arts du feu*, the arts of fire, because firing is an essential process in their manufacture.

The organic materials are by-products of vegetable and animal growth, such as wood and cotton from trees and plants, wool and skin from animals. These materials give rise to the following principal divisions:

Woodwork, Textiles, Leatherwork. There are other divisions, such as Paperwork, but these arts are of minor im-

portance, and the aesthetic principles applicable to them are easily deduced from the general principles which arise in connection with the basic industrial arts.

In addition to the arts which arise out of the working of these various materials, there is an art which consists in assembling and combining ready-made units from the primary industrial arts. This art we may call the art of

Construction, and this art includes anything from combining metalwork and woodwork on a piece of furniture to the building of a house, a factory, or a city.

working

Apart from the determination of form by the physical nature of the material used, there are certain subsidiary considerations which arise out of the means that must be used to work and control the material—the limitations of the tools and machines, the degree of intervention of the human element, and general social and economic conditions of manufacture.

purpose or function

There is perhaps little distinction between these two words; we tend to use "purpose" of simple things we handle, like jugs and knives, and "function" of machines which act more independently, like railway engines and houses (in the sense of Le Corbusier's phrase, "a house is a machine to live in"). But since the word "function" implies the mode of action by which an object fulfills its purpose, I shall more generally use this word.

That an object made for use should necessarily fulfill its function would seem to be an elementary consideration, but it is one which has been constantly neglected, and usually neglected in the name of art. One of the uses art

was put to by nineteenth-century industrialists was to hide defects. Scars in pottery could be painted over with ornament, defects of casting iron could be disguised by complicated relief ornament; and, apart from such subterfuges, it was felt that if an object could claim to be beautiful, it might be excused being thoroughly useful.

Now we tend to the opposite error, and if an object is thoroughly useful, there is an assumption that it must be beautiful. The accidental beauty of many objects made primarily for use has given countenance to this error, but it requires a somewhat mystical theory of aesthetics to find any *necessary* connection between beauty and function. There is no art without a certain degree of disinterestedness—a preference for form for its own sake, for its rational or intuitive appeal. And art implies an intention to produce an aesthetic effect. The whole purpose of art in industry, and of the principles we are now trying to elucidate, is to reconcile the necessary qualities of an object (material, working, and function) with incidental qualities of beauty. That these incidental qualities are no less necessary to the biological process of life is a philosophical assumption which this book takes for granted.

We may now turn to the various divisions of industrial art and see to what extent the form of the objects made is determined by considerations of:

1. Material.
2. Mode of working.
3. Function of object.

material aspects—inorganic

POTTERY

material

All pottery Is made from a plastic material, clay, which when fired in a kiln receives a fixed and brittle form.

Plasticity implies an unlimited variety of forms, and within the limits of technique and function, the forms of pottery are endless. At one end a plain tile or simple cup; at the other end exact replicas of natural objects, such as flowers, or models of the human figure.

working

Pottery is of two extreme kinds—earthenware and porcelain. The difference between these kinds is due (i) to selection and degree of refinement in the clays used; and (ii) to the degree of heat to which the vessel is submitted.

A relatively low degree of heat and a relatively unrefined clay produces *earthenware,* which, since it is of a porous nature, must be glazed to make it impervious. Glazes are of various kinds (alkaline, lead, feldspathic, and salt), but their essential nature is glassy or enamel-like, and they can be applied as an impervious covering to the porous body of the earthenware vessel. Apart from this utilitarian consideration, their function is decorative and will be dealt with in Part 3.

In *porcelain,* the application of a higher degree of heat

fuses the clay into a homogeneous and impervious material, glassy in nature. A glaze becomes unnecessary, though sometimes one is applied for decorative purposes.

Stoneware is of the same nature as porcelain, but coarser in texture.

There are two modes of giving form to the plastic material of pottery: molding and throwing.

In its primitive stage, molding should more properly be called modeling. The plastic clay is shaped in the hands, directly if a small vessel is required, or otherwise by coiling a rope of clay round and round in superimposed spirals until the required shape is roughly built; it can then be pressed together and smoothed.

Molding proper consists in making a block or matrix of wood or any other suitable material, and then shaping the clay round the block or within the matrix, and smoothing it out to the required thickness. A more modern method, introduced into England during the eighteenth century, is known as "casting," and consists of pouring a liquid mixture of clay and water into an absorbent mold, into which the water in the mixture soaks, leaving a thin deposit of clay, which is ready for firing when the molds have been removed.

Though modeling or molding is the original method of making pottery, and a perfectly legitimate method, the material is more often associated with the technique of *throwing.*

The potter's wheel, the machine by means of which clay is thrown, is a comparatively late invention in the history of pottery. It may have been known in the fifth millennium B.C., but it remained an extremely primitive machine until a few centuries before the Christian era. At first merely a disk on a spindle rotated by hand, the spindle was then

increased in length and fixed to a lower disk, which could be rotated by the potter's foot, leaving both hands free to mold the clay. Not until the seventeenth century were wheels invented to work with a pulley and cord. In the industrial age, with the wheel rotated by steam or electric power, the essential character of the potter's wheel remains unchanged. It was a machine from beginning to end. At the wheel, the potter throws a pad of properly prepared clay into the center of his disk, sets it rotating, and then presses down on the clay with his thumbs, using his fingers on the outside of the pad to press inward toward his thumbs. The plastic clay, driven round by the wheel, rises between the pressure of the thumbs and fingers. As it gets larger, the potter has to separate his hands and use one for the inside, the other for the outside of the vessel. The clay is very plastic, and obeys the least inclination or pressure of the fingers. Subject to the purpose for which the vessel is required, the potter may be guided by his instinct or by a given measure. If left to his instincts, then that instinct is, or should be, an aesthetic apprehension of form, an abstract intuition in the sense in which we have defined the term. If he is working to measure, he will get as near as he can in the uncertain plasticity of his material, leaving exactitude for further processes of refinement.

With its form thus finally or roughly determined, the clay vessel is then set aside to dry, and in due course is put into a kiln and fired. Firing causes the vessel to shrink, and plays an important part in various decorative processes; but the essential form of the vessel remains unchanged.

If a particular precision of form is desired, then before the vessel is put into the kiln, but when it is dry enough and cohesive enough to handle, it is put onto a lathe, and its surface given the exact precision and smoothness required.

This process is sometimes repeated on the fired vessel, in those rare cases when a polish rather than a glaze is required.

The process of glazing, which may be contemporaneous with or subsequent to the firing, is for the present left out of consideration, but a futher process should be mentioned. Not all vessels are thrown or molded in one piece; they may be made in sections, and in that case before firing the sections are assembled, and any subsidiary parts, like handles and spouts, added; they are "luted" on by means of a wet solution of clay, which acts as an adhesive. In this process of assembly, a certain amount of constructive art may come into play.

As a result of the working of the material, the vessel is given a final texture, and texture plays a great part in the aesthetic appreciation of pottery, especially in the Far East. The texture of unglazed earthenware pots often has a visual appeal, but is unpleasant to handle. But with rare exceptions, the unglazed earthenware pot is a thing of the past; it survives functionally only in such objects as butter coolers and water jugs, since the evaporation of moisture from their porous walls tends to keep the contents cool. Functional or utilitarian considerations have also condemned enameled earthenware, which has perhaps the pleasantest texture of all forms of pottery; but in use it chips away from the soft earthenware underneath, and will not stand the heat of ovens. The normal pottery in present use, a material intermediate between earthenware and porcelain, has little charm of texture beyond its smoothness; and modern porcelains have lost the softness and depth of earlier products. But if pleasantness of texture were once again to be considered a desirable quality of pottery, there is nothing in modern processes to prevent its

attainment; there might be as many qualities of texture in pottery as there are in paper, for example. As it is, the machine-made porcelains of Germany (Berlin) and France (Limoges) have more textural appeal than most kinds.

function

Though pottery has always had countless uses, and as "raw" material may play a large part in such processes as building, its primary use has always been for the provision of various kinds of vessels—drinking vessels, retaining vessels, and eating vessels. The purpose or use of the vessels will determine the general forms which the potter gives to his vessels in the process of manufacture.

The norm of a hollow form in a tensile, cohesive material like clay, from which all other forms might be said to deviate, is the hollow sphere. The same is true of the related material, glass, which we shall deal with in the next section, and of various metals. But to be useful, the sphere must be open. If the object of the vessel is to retain a maximum quantity, the opening will be as small as possible; if the object is to give a maximum of access to the contents, the opening will be as wide as possible, that is to say, one-half of the hollow sphere. An opening less than half the surface gives us the type of the jar or vase; half or less of the sphere would make a bowl, until, when only a quarter or less of the sphere is left, we get the type of the dish or plate.

To any of these rudimentary forms, the addition of a rim or neck to make access convenient to the lips, or to strengthen the thin edge, and the provision of a foot-ring to enable the vessel to stand, give rise to the development of secondary features. The provision of handles for holding the vessel is another secondary feature.

Such analysis may seem elementary, but it is only by realizing the essential elements in form that we arrive at the beauty of its variations. From the primary element, the hollow sphere which we call the body of the vessel, and the secondary elements of neck and foot and handles, we can construct innumerable sequences of proportion, some of them regular and harmonic, as in certain types of Greek vases, others more irregular but still "right" to the instinctive judgment of the maker and user.

The actual use of the vessel determines minor variations of form. If it is a heavy vessel, it may have to be provided with ring handles through which a rope can be threaded. If it is a lifting vessel, normally it will have two handles. If it is a pouring vessel, it will have one handle and a spout. If it is a drinking vessel, it will have a handle, as otherwise it is inconvenient to hold. If it is an eating vessel, it will combine ease of access and, when to be used along with utensils that involve pressure (the knife and fork), a flatness of surface with, however, a retaining side. Even such a consideration as that salt is taken with meat, and therefore the rim of a meat plate should be capable of retaining salt, must be remembered, and reckoned in the solution of the aesthetic problem. A spout on a pouring vessel must pour without dripping, and the handle on a vessel for hot liquids (such as a teapot) must be wide enough to keep the fingers out of contact with the body of the vessel.

All these functional necessities, though they add to the complication of the artist's task in designing a vessel, give him the necessary elements out of which he can produce the variety of his forms. To take one simple case: the balance of the spout and handle of a teapot, with each other and with the body of the pot, is an aesthetic problem

to which no artist need be ashamed to devote his attention. There is not only the problem of balancing two linear forms, each with a distinct function, against each other, but these forms must both accord with the three-dimensional volume of the body of the pot. The correct solution of this problem is one of the rarest of aesthetic achievements.

This discussion of the relation of form to function in pottery has envisaged the thrown vessel. But in this machine age, the thrown vessel has to some extent been replaced by the molded or cast vessel, and we must therefore ask whether any further considerations arise from this fact. Actually, most of the cast pots of today tend to imitate thrown forms, and the legitimacy of this may be questioned. If there were any question of the efficiency of the forms natural to thrown vessels, this would be an objection difficult to meet. But actually the normal forms assumed by clay on the wheel are extremely practical. Their rounded shapes are clean and hygienic, and follow the strongest lines of force that a brittle material can take. When metal vessels, such as silver teapots, take on the same shape as pottery vessels, this is not so much a case of imitation, as the result of obeying the same laws of efficiency.

But whether a cast pottery vessel which imitates the shape of a thrown vessel can have the same aesthetic value, is another question altogether. In a book already referred to,* the question was answered in the following way:

Forms capable of being multiplied without variation from a single original model cannot but have a much smaller interest than those in which each individual piece is the direct expression of the potter's instinct. The molds

* *English Pottery.* By Bernard Rackham and Herbert Read (London, 1924), p. 129.

used for casting pottery are, it is true, made by hand, but their employment is a purely mechanical process; moreover, the handwork involved in the cutting of them is of quite a different order from that of the potter's wheel. Both processes, it is true—casting and throwing—depend for their results on the cohesive quality of clay, but the stuff as it whirls and changes shape on the wheel under the hand gains, in a physical sense, a toughness and power to withstand strain which is not without its psychological appeal. Such vital quality in the finished work can never come from the passive settling of particles of clay on the inner side of a porous mold.

In the Introduction to that book, we had defined what we meant by this quality of vitality in pottery:

All pottery should possess symmetry or some more subtle balance. This need is a general aesthetic one, common to all visual arts. But in the case of an earthenware vessel, thrown on a revolving wheel, symmetry is a necessity of good technique no less than of good art; a well-thrown vessel is a vessel that coheres by the balance of its symmetrically opposed parts. In addition to symmetry or balance, a good vessel possesses *vitality*, a quality due to the instinct of the potter. Symmetry and balance do not necessarily imply vitality, which is a less obvious characteristic, due to the suggestibility of the lines and mass of a vessel. The eye registers and the mind experiences in the contemplation of energetic lines and masses a sense of movement, rhythm, or harmony which may indeed be the prime cause of all aesthetic pleasure.

As I now see the problem, in the light of the general principles I have discussed in Part 1, vitality is not the simple unique quality we then supposed it to be. Actually the last sentence I have quoted runs together two kinds of vitality

which I would now make distinct, calling one ("energetic lines and masses") mechanic dynamism, and the other ("a sense of movement, rhythm") organic vitality. The relative value of these two kinds of vitality is discussed on another page. What I want to suggest in this context is that the vitality proper to thrown pots is organic, and the "vitality" proper to cast pots is mechanical. What the cast pot loses in individuality, it gains in precision. Its precision is in the service of a pattern; the pattern is a human invention—it should be the invention of an artist.

GLASS

Glass, like pottery, is made from a material reduced to a plastic state, and becomes, when finished, a brittle material. Its forms therefore bear a general resemblance to the forms of pottery, but since in its nature and its mode of working the material is essentially different from pottery, different considerations arise.

material

Ruskin, in an Appendix to the second volume of *The Stones of Venice,* described the peculiar characters of glass as two, namely, its *ductility* when heated, and its *transparency* when cold, both nearly perfect. "In its employment for vessels, we ought always to exhibit its ductility, and in its employment for windows, its transparency. All work in glass is bad which does not, with a loud voice, proclaim one or other of these great qualities." *Ductility,* like plasticity in clay, implies an unlimited variety of forms, but we might describe the essential form of a glass vessel as *the bubble.* There are many kinds of glass, but normally

it is made from a silicate material, like sand, rendered soluble by an admixture of soda or potash or both; it may be colored by metallic oxides held in solution or in suspension, or it may be made opaque by producing crystallization in the process of cooling. But normally the process of cooling is controlled so as to produce a clear glass, transparency or translucency being the peculiar quality of this material.

Ruskin made a further qualification: "*All cut glass* is barbarous: for cutting conceals its ductility, and confuses it with crystal." But such a point of view is too extreme. One of the qualities developed by glass, especially that sub-variety known as glass of lead, is luster; and luster in glass is a quality that may legitimately be exploited. The real objection to most types of nineteenth-century cut glass is not the cutting in itself, but the unpleasant tactile surface which it entails. The shallow cutting found in the best types of eighteenth-century glass has a definite aesthetic appeal, which appears again in various types of modern glass, where the cutting is used with discretion.

Ruskin further held that precision was not a quality to be aimed at in glass vessels. "All very neat, finished, and perfect form in glass is barbarous: for this fails in proclaiming another of its great virtues; namely, the ease with which its light substance can be moulded or blown into any form, so long as perfect accuracy be not required. In metal, which, even when heated enough to be thoroughly malleable, retains yet such weight and consistency as render it susceptible of the finest handling and retention of the most delicate form, great precision of workmanship is admissible; but in glass, which when once softened must be blown or moulded, not hammered, and which is liable to lose, by contraction or subsidence, the finest of the forms

given to it, no delicate outlines are to be attempted, but only such fantastic and fickle grace as the mind of the workman can conceive and execute on the instant. The more wild, extravagant, and grotesque in their gracefulness the forms are, the better. No material is so adapted for giving full play to the imagination, but it must not be wrought with refinement or painfulness, still less with costliness. For as in gratitude we are to proclaim its virtues, so in all honesty we are to confess its imperfections; and while we triumphantly set forth its transparency, we are also frankly to admit its fragility, and therefore not to waste much time upon it, nor put any real art into it when intended for daily use. No workman ought ever to spend more than an hour in the making of any glass vessel."

Ruskin's principles still hold good of all forms of blown glass, but the introduction of the mold and of the pressing machine makes some modifications necessary.

working

Glass is melted in a crucible, from which a convenient amount is extracted on the end of a hollow rod (blowing iron). The blob of viscous glass is rolled on a polished slab of iron, and then a hollow form is produced by blowing down the hollow rod. The form thus produced is naturally spherical. As it is blown, its shape can be modified by shaping the still viscous glass with various hand tools, such as tongs, pincers, and scissors, or by blowing it into a mold of the required shape. Such is the normal or original method of making a glass vessel.

This method is still in general use, but machines for blowing and for pressing glass are now used for many commercial kinds of glassware. Separate parts of a glass vessel may be molded separately, and then fused together.

Pressed glass takes its form from a mold, but is forced in by a plunger. It is thus treated like any other molten material, and can assume any form appropriate to such materials.

Rough edges in any of these processes may be removed by exposing the vessel to heat, or by grinding and polishing. Pressed glass, of necessity, must be of a thicker, tougher texture than blown glass or molded glass, and thus sacrifices one of the possibilities of the material— delicacy or grace. But when such glass becomes functional, as in modern fireproof glassware for cooking, the appropriateness of its thickness introduces a different criterion, which may yet have its aesthetic aspect.

Modern methods of molding glass have also made great precision possible, and thus still another quality thought desirable by Ruskin, a certain casualness of form, tends to disappear. But precision is found to have its own aesthetic values, and while we can still appreciate the unique and individual grace of a hand-blown Venetian glass, the perfect grace and regularity of a modern glass can have an equal if not a greater appeal.

function

Glass has many uses apart from its use for all kinds of vessels, and some of these uses, as in lamps and lighting fittings, play a considerable part in the total aesthetic effect of a structural work of art. Its use is continually being extended in modern architecture, and it is difficult to fix the limits of its possible application. Plate glass is used, not only for windows and mirrors, but as a decorative and protective surface in various kinds of furniture and interior decoration. But its most effective use, from an aesthetic point of view, is still in the provision of vessels, especially

vessels for cold liquids and liquids which have a color appeal of their own. For such purposes it is superior to pottery; its texture is equally pleasant to hand and lip, and its transparency or translucency adds light to color.

In so far as form is determined by function, the observations made in the case of pottery apply generally to glass; two considerations only modify them to some degree. The greater fragility of glass tends to limit the form of glass vessels in the direction of simplicity; while the slipperiness of glass makes a firmer mode of handling necessary—hence the glass tumbler as opposed to the pottery mug.

The problem of cut glass is, as already indicated, best considered from this functional point of view. Flat facets are often cut on tumblers to provide a better hold, and are then perfectly satisfactory from an aesthetic point of view. In fact, the transition from the round cylinder to a polyhedral surface is often a definite aesthetic grace. But the deep and complicated cutting of nineteenth-century glassware not only destroys the plastic outline of the vessel (and fails to substitute any significant glyptic outline, such as we get in the best types of vessels cut from rock crystal), but even destroys the proper texture and "color" of the glass.

METALWORK

Metals may be grouped in various ways—their degree of preciousness is the usual one. They may also be considered as either natural products of the earth, or as artificial alloys. From an aesthetic point of view, probably their degree of ductility or malleability, and other physical properties, are the most important considerations.

Gold, silver, and iron are the metals most used in their natural state for the making of useful objects. Gold and silver occupy a special place owing to their preciousness, and they share certain physical qualities, and therefore technical processes, in common. The chief characteristic of gold and silver, as compared with iron, is their exceptional durability; they are not subject to the rapid deterioration through rust which quickly destroys all unprotected ironwork. A further characteristic is their extreme ductility and pliancy, even in their natural and unheated state. This quality enables them to be drawn out into fine wires or thin sheets, and to be worked to the utmost minuteness— a characteristic of which only too much advantage has been taken in the past.

Iron is ductile and malleable when red-hot, and indeed in this state is the most securely plastic of all materials. Two heated surfaces of iron are easily welded together, and thus it is an ideal material for objects involving structural design.

Copper and tin are metals rarely used separately for making objects, but in combination they form the alloy *bronze,* which, because of its great fluidity when melted, its slightness of contraction on solidifying, together with its compactness and hardness, is an ideal material to cast in molds. If properly tempered and annealed, it becomes ductile and malleable, and forms a cheap substitute for gold and silver, especially when *plated* with a thin coating of these materials. *Brass,* an alloy of copper and zinc, is a still cheaper substitute for the precious metals.

The most typical of modern alloys is steel, a combination of iron and a small quantity of carbon. Its use is mainly

structural, but it is used for all kinds of tools and utensils, and in its improved form, as stainless steel, is now employed for many other purposes—especially for all kinds of vessels and as a material for interior decoration. Alternatively, a stainless surface of nickel or chromium may be applied as a plating.

Among various metals whose commercial production has been made possible by scientific discovery, an important place is taken by *aluminum,* which, owing to its extreme lightness, as well as its cleanliness and durability, tends to usurp the place not only of other metals, but even of pottery.

working

Metals like gold and silver, though in a general sense plastic, like clay, are in their working either *ductile,* which implies that they can be drawn out into wires, or *malleable,* which is to say, capable of being shaped into form by hammering. A silver bowl, for example, is shaped from sheet silver. A circular disk of the metal is cut from the sheet and hammered against a wooden block, regularly and systematically, so that an edge is thrown up all round. If necessary, the silver must be softened by annealing, and at various stages in the process different shapes and different weights of hammers will be used. But as in clay and glass, plasticity is the key to the forms naturally assumed by malleable metals, and actually the forms of silver vessels, for example, have corresponded closely with the forms of earthenware and glass vessels. The ease with which sheet silver will assume certain forms (the cylindrical and conical) does, however, introduce a certain bias in the forms adopted. The tall silver coffee-can with the straight handle and spout, typical of the eighteenth century, is a

form arising naturally out of this material consideration.

The hammer marks left by the hammering technique are often left visible, and the irregularly faceted surface thus given has a definite appeal. But precision, and the inherent quality of brightness, more often demand a smoothed and polished surface. Forms resulting from other methods of working, such as casting, are sometimes given an artificial "hammered" effect, which is of course an absurd affectation, and contrary to all aesthetic principles.

Casting, and molding or pressing, are the normal modern methods of working metals, and the general principles of plastic form apply to metal as to pottery and glass. Metal, however, is the material most capable of precision, and the tendency under machine production has rightly been to exploit this quality. Precision, and dependability under mechanical processes of production, have also led to a greater standardization of forms in metal, or rather, to the employment of metal wherever possible for articles in which a standardized form is desirable.

The invention of rustless steel, and of the chromium-plating process, has greatly extended the uses of metal, especially in the manufacture of furniture and architectural fittings. These uses will be considered when we come to deal with structural art.

function

The uses of metal are very numerous, and include not only the provision of all kinds of vessels, in which use it rivals pottery and glass, but its greater toughness renders it suitable for all kinds of purposes for which brittle materials would be quite useless—handles, hinges, locks and keys, grilles and gates, and all appurtenances that come into contact with fire. In vessels, pottery and glass have the

advantage (except in subtle conjunctions, such as pewter and beer) in that they are tasteless. Porcelain and glass are pleasanter to the lips, and for this reason alone these materials are not likely to be replaced by the unbrittle metals. The purpose of metal vessels determines their form in very much the same way as we have found the forms of pottery vessels to be determined, and metal jugs, bowls, plates, and dishes for this reason follow the general principles we have already considered. More individual are the forms assumed by metal utensils and implements. Because metal when tempered is capable of being ground to a sharp edge, it is the natural material for all cutting and piercing instruments, most obviously for knives and forks (the spoon is more properly considered as a vessel—we even speak of the *bowl* of a spoon). The forms assumed by ordinary domestic knives illustrate very neatly the whole principle of form and function. They must have a handle fit and firm to hold; and a blade that gives the right edge and direction for cutting. The direction of cutting will vary in different uses: the bread knife and the carving knife cut over relatively large surfaces, and horizontally, without a solid ground to cut against; the meat knife cuts vertically against a hard plate; the butter knife and the palette knife must be capable of spreading the material they cut; and so on. Up to the beginning of the industrial age, these various functions were faithfully reflected in the form of the blade and handle; in the nineteenth century, in England if not elsewhere, there was a tendency to reduce all knives to a straight handle and a straight blade with rounded end. The difference in functional efficiency between this standardized knife and the old handmade knife may not have been very appreciable; but it was reflected in the relative aesthetic values of the

types. This difference has now been realized, especially in Germany, but the remedy has not been a return to hand-made knives, but the production of a variety of standard types adapted to a variety of functions. Standardization, it cannot be too often repeated, does not imply one standard; it does imply one standard for every distinct function. And even that standard is an absolute to which there will be many approximations.

material aspects — organic

WOODWORK

We now come to materials which are organic in origin. Generally they differ from inorganic materials in being less durable, but they have other qualities, such as soft-ness of texture and warmth to the touch, which make them indispensable for many of the objects of daily use.

material

Wooden objects were originally cut from the block, and wood was thus treated like any other plastic material. Wooden bowls and dishes (platters) therefore generally have the same type-forms as pottery. Such objects are still made for a variety of purposes (breadboards, fruit bowls, etc.), and their aesthetic qualities, under the machine-driven lathe, are similar to those of pottery. The beauty of precision has replaced the individual charm of the hand-made object; other qualities, such as those of color and texture, remain constant.

Wood, as a material, consists of bundles of fibers run-

ning in the direction of the growth of the original tree. Because of its structure, wood easily splits in the direction of growth, and this has to be taken into account in the working of the material. The fibrous nature of wood gives, according to the direction in which it is cut, a variegated pattern known as the "grain," and this grain in wood is a decorative quality that has always been exploited. The character of the grain naturally varies according to the habits of growth of different trees; the grain of a straight-growing tree like pine is comparatively uninteresting, while that of Italian walnut, lime, sycamore, or pear is more complex and attractive. The decorative appeal of grain in wood is essentially the appeal of abstract pattern, a fact not recognized by people who have an eye for graining but no eye for the same kind of appeal in modern abstract painting.

Wood is now rarely worked from the block, but is sawn into planks and posts of standard sizes, and as such comes to the factory or workshop. As such it is primarily a structural material, to be used in the rough (carpentry) or to be subdivided and planed for finer work (joinery). Modern methods of preparing wood have greatly extended its scope and workability. It can now be cut by a process which "uncoils" the trunk from the bark to the pith, producing thin sheets of a wide area; these sheets are superimposed one on another, with the direction of the grain alternating, and then glued together under pressure. The resulting material, known as plywood, is strong and light, and easily sawn, and is now largely used in constructions, such as furniture, which present large even surfaces.

One of the disadvantages of wood is its liability to warp. This is normally overcome by "seasoning" the raw material (timber), a process which may take many years. Even then,

climatic conditions may work on wood, and produce warping. The laminated structure of plywood, with its counterstress of grain, has largely obviated this disadvantage in the material, and wood can now be used for structural purposes for which formerly it would have been totally unsuited. This is but one case of machine methods of production extending the scope and utility of a material.

Under the influence of damp heat (steam) wood becomes pliable, and this characteristic gives rise to a quite distinct branch of woodwork (bent-wood furniture). This technique has been used largely for the construction of cheap chairs, and good forms have been evolved, totally distinct from the normal "constructed" or joinered wood chair. Such furniture now has a rival in steel-tube furniture, which is more durable and brighter; but its greater lightness, and the pleasantness of wood to the touch, still give bent-wood furniture a place on the market.

working

The uses to which wood can be put are innumerable, but are mostly included under furniture and the interior fittings of houses. The chest, the table, and the chair are the normal types of furniture. The simple form of the chest is a box with a lid; but a chest of drawers is merely a device for superimposing one box on the top of another. Precision is important, for drawers and lids must open easily, and yet be tight enough to exclude dust and damp. Apart from ability to contain the objects for which it is intended, questions of function are not likely to interfere with the direct application of aesthetic standards of harmony and proportion.

The table has more functional variety. Its intended use determines its size and height, and the kind of wood from

which it is to be made. If it is a table to sit at, for eating or for writing, then it should be designed in conjunction with the accompanying chair. The height of the seat of the chair is determined by the comfort and convenience of the user; and since human beings are themselves such variable quantities, many standards will be desirable. But having determined a standard of height and size for the chair, the height of the table will follow automatically: it must be high enough to admit the sitter's legs underneath it, and not too high to eat from or write on with comfort. These are elementary considerations, but how often are they observed?

For sitting upright, actually the stool or the bench is all that is functionally necessary. But even in chairs designed for use at a table, we occasionally wish to relax; and this double function will give the designer a difficult problem —but one which was solved very satisfactorily in the so-called "Windsor" chair of the eighteenth century (Figure 70). Chairs purely for rest and relaxation present further problems, and though good forms were evolved traditionally, especially in England in the eighteenth century, modern manners, and perhaps to some extent modern medical science, have given rise to a much more thorough notion of relaxation (accompanied by a loss of dignity) and the easy chair has had to adapt itself to these needs. An easy chair of pleasing lines has been evolved, but only slowly and painfully, leaving in its traces some of the ugliest and most shapeless forms ever devised by man. This type of chair, however, is rarely more than wooden in skeleton, the skeleton being covered with springs and cushions and finally upholstered in fabric. The flexibility of plywood, helped by new methods of bending multiple plies, has recently led to the invention of a new type of

easy chair, constructed entirely of wood, extremely economical in design, and capable of serial mass production (Figure 78).

TEXTILES

In considering wood as a material, we noted its essentially fibrous nature. Its working runs counter to its fibrous nature, and depends on the cohesion of the fibers. All textiles are also made of fibrous materials, but work with the fiber, taking full advantage of the capacity of the material to disintegrate into threads, and in that state to be woven, knitted, knotted, plaited, and felted. The earliest forms of weaving were done with osiers and rushes, and thus there is a natural connection between these two main groups of organic material.

material

Though the materials from which textile fabrics can be made are of great variety, and include not only vegetable fibers like flax and jute, but animal-hair fibers like wool, the fibrous excretion of the silk moth, various kinds of artificial fiber, and even the fibrous mineral asbestos, yet all have an essentially similar physical structure (colloidal) which permits them to be used in textile manufacture. When the fiber is virtually continuous in length, as in silk, an appropriate number of threads are twisted together to make a workable thread; when the fibers are limited and varied in length, they undergo various processes known as scutching, hackling, combing, etc., but finally they are twisted into yarns, which is a workable thread or twine of varying degrees of cohesion. When the raw fibers are too

short and irregular to submit to this process, they are so treated that they tangle up and agglomerate into the fabric known as felt. Paper is a fabric of an analogous nature, consisting of an agglomeration of minute fibers deposited from a liquid pulp. But felt and paper remain essentially raw materials, and questions of aesthetic form do not arise in connection with them. We confine ourselves, therefore, to various kinds of textiles made from spun threads.

working

Weaving * is the typical method of working threadlike materials. It consists of interlacing two or more series of threads at right angles, the longitudinal threads being called the warp, the transverse the weft. There are many varieties of weaving; for example, one warp may be combined with one weft, in parallel series; or two warps with one weft, or two wefts with one warp; wefts of one material combined with warps of another material, or vice versa; piled fabrics, in which a portion of the weft or warp is cut so that the threads assume a vertical position; crossed weaving, in which the warp threads intertwist to produce effects intermediate between weaving and lacework. Essentially, the object of all methods of weaving is to produce a *texture*, that is to say, a surface of cloth whose appeal consists solely in its tactile properties, or the visual apprehension of such tactile properties. Most fabrics are made to be worn on the body or to come into contact with the body on furniture; they must therefore appeal in the first instance to the sense of touch. For some purposes we like a

* *Knitting* is a process distinct from weaving; it employs only one series of yarns, which are bound over, under, and round each other by needles to form a texture without the crossing of threads at right angles, which is the distinctive characteristic of a pure woven construction.

smooth and silky surface; for others a soft and warm surface; for others still, a rough and stimulating surface. For most uses, durability is an important consideration.

If the constituent threads are homogeneous in texture and color, surface qualities will be all that result from the process of weaving. But a difference in texture as between warp and weft, and especially a difference in color, will produce a pattern in the fabric. A simple weaving scheme with a regular variation in color and sequence will produce a check-pattern, but the greater the degree of variation, the greater the complexity of pattern. The variation can be so controlled that a specified pattern can be produced at will. Such patterns, however, come under the heading of ornament, and will be considered in Part 3.

It will be seen that there is a fundamental difference between textiles and the other materials we have considered in relation to formal aesthetic qualities. In pottery, glass, metalwork, and woodwork we are concerned with materials capable of assuming plastic three-dimensional shapes; in textiles we are concerned with a surface quality of two dimensions only. If the first group of materials is by analogy sculptural, fabrics are painterly, and even can be used with a pictorial intention, as in tapestries. The aim of the designer of fabrics should, however, respect the nature of the material and the process of working it; a good textile is frankly fibrous in its appearance, and makes no attempt to disguise warp and weft, even in the production of ornament.

function

The function of the fabric will often determine its surface qualities, its compactness, weight, warmth, etc. The adaptation of weave and constituent thread to various modes of

apparel is an obvious functional consideration. Some purposes require elasticity in the fabric, others inelasticity. Curtain fabrics should have sufficient weight or stiffness to hang properly; upholstering fabrics should be strong and uncrushable. But these, and other considerations such as color-fastness when the fabrics are dyed, are questions of efficiency rather than of form.

LEATHERWORK

Leather, like most textiles, may be considered as an organic material rendered susceptible to machine production by various preliminary processes, whose object is to render the hides or skins of animals imputrescible and at the same time supple.

material

There is a large variety of leathers, differing according to the physical nature of the animal from which the original skin or hide is taken, and according to the nature of the processing which the raw material then undergoes. Leathers are usually divided into heavy and light grades, the former deriving from large animals like the cow and bull, the latter from smaller animals like the sheep, goat, pig, seal, lizard, etc. There is a considerable difference in quality according to the habitat of these animals—hill cattle, for example, providing a tougher hide than lowland cattle.

working

Leather is prepared for manufacture by three processes, the chief of which is *tanning*. The hides or skins are treated with tannin or tannic acid, not only to prevent putrefaction,

but to render the material supple and, in some cases, impervious. In another process, called *tawing,* the skins are prepared with mineral salts. In the third process, *chamoised* leather, the lighter leathers are rendered imputrescible and extra supple by treatment with oils and fats.

An essential stage in the working of all leathers is known as *currying,* which involves working oil or grease into the tanned hide to render it pliable and to increase its strength. There are several other secondary processes, such as paring the leather to an even thickness, waxing it and dressing it in various ways.

The different materials used for tanning (mostly derived from plants), the different methods of processing and finishing, result in a large variety of colors and textures—even assuming the same original kind of hide. The final aesthetic appeal is unique—"there is nothing like leather"—and is a combination of visual and tactile sensations.

Once the material is ready for use, it is made up into appropriate articles in the same way that a textile fabric is made up—that is to say, it is cut, pressed, and sewn, these processes now being for the most part carried out by machinery requiring the service of skilled craftsmen.

function

Leather is used principally for articles of clothing, such as gloves and shoes; for trunks, handbags, and various other kinds of containers; for sports articles, such as footballs; and for bookbinding.

construction

Associated with the handicraft methods of production is the notion of a single unit, an object made and controlled by one individual, a masterpiece. Such unity of attention is comparatively rare in machine production, which implies division of labor. Most objects are made up of several units, and under machine production each unit may be the product of a separate machine, tended by a separate individual. This was one of the main indictments brought against machine production by critics like Ruskin and Morris, and we still frequently hear it. Aesthetically it is argued that an object cannot be a work of art which is not the direct product of an artist's vision and will; art, as we have already seen, is so definitely controlled by such subjective factors as a sensibility to the physical nature of the raw material, that this control is more than likely to disappear when distributed among several individuals. Ethically it is argued that there can be no joy in work for which the individual is not personally responsible, and that where there is no joy there will be no goodness. But even if we assume that these factors have disappeared under machine production, another has entered which may compensate for them. This is the art of *construction*.

The word construction began to be used during the nineteenth century for the activity of the civil engineer. The engineers who built the Crystal Palace, the Eiffel Tower, and the Forth Bridge could not, it was felt, be dignified with the name of architect. Engineer was too vague and

general, and even civil engineer not definite enough. So the phrase "constructive engineer," or simply the "constructor," came into use, and we even began, faced with such phenomena as the Forth Bridge, to speak of constructive art. "All that it lacks to make it architecture," said a certain professor of the Forth Bridge, "is ornament." And there are still critics who would make a distinction of *kind* between, say, the Forth Bridge and St. Paul's Cathedral. They would perhaps find it more difficult to make the same distinction between the Forth Bridge and a Gothic cathedral. "The Architecture of Humanism" is the apt title of the most thorough of these criticisms. But the late Geoffrey Scott, in attacking "the mechanical fallacy" which he assumed to underlie modern architecture, was really missing the point; and so, I think, are the other critics I have mentioned. The advocates of modern architecture are perhaps to blame, for they have confused the issue by claiming that fulfillment of purpose, or the creation of perfect, and therefore beautiful, efficiency, is the proper aim of architecture. That functional efficiency and beauty do often coincide may be admitted; we have already had the example of the motorcar. The mistake is to assume that the functional efficiency is the cause of the beauty; *because* functional, *therefore* beautiful. That is not the true logic of the case.

Le Corbusier has drawn a distinction between the engineer and the constructor which gives the proper justification for the new word. Engineering is analysis and calculation; construction is synthesis and creation. The engineer, so to speak, relies on his measuring rod, and is satisfied if the result works. But a constructor, such as Le Corbusier himself, has a passion for order, and order is harmony, is beauty. Though he is in revolt against all academic conventions, Le Corbusier would claim that

nevertheless he embodies the true tradition. We speak of the "orders" of architecture; but where there are so many orders, Le Corbusier would ask, how can there be order? Le Corbusier has studied the construction of the Parthenon and the Capitol, and the underlying principles of order and harmony which he finds in these classical buildings he finds embodied also in a monastery in Italy, in the Eiffel Tower, and in a modern transatlantic liner—everywhere the same principles of economy, efficiency, and freedom. Different functions lead to different forms, but in every case the same reliance on order, harmony, and the beauty of the straight line.

It will be seen that we return to the distinction between humanistic and abstract art which was elaborated in Part 1 of this book. The architecture of humanism exists in its own right, but it is not an exclusive right. It is an architecture appealing primarily to our literary and intellectual sentiments. With it we may contrast an entirely different order of architecture, appealing to our sense of order and abstract harmony; and as in the types of abstract art already considered, the appeal of abstract architecture, of constructive architecture, may be either rational or intuitive. A building may be constructed according to definite canons of proportion, as the Parthenon seems to have been constructed; or it may seek a freer harmony of asymmetrical balance, an infinite counterpoint of lines and planes determined by the aesthetic sensibility of the constructor.

The critics of modern architecture, of the architecture of Gropius, Le Corbusier, Mies van der Rohe, Mallet-Stevens, or Alvar Aalto, entirely fail to appreciate this other harmony of abstract relations. They look at a modern building and admit its efficiency, but deny its beauty.

Beauty to them is a question of ornament—of columns and capitals, of swags and cartouches, cornices and fretting. Thus they repeat, on the larger scale of architecture, the fallacy which has confused the whole development of industrial art.

Between the construction of a steel and concrete house or bridge, and the assembly of a smaller object such as a machine-made chair or table or suitcase, there is only a difference of degree. The same principles are applied— the principles of canonical or rational order, or the principles of intuitive order. The designer of a modern chair, for example, is working with certain standardized materials —steel tubing of a certain gauge, to take an extreme example. The constructive engineer is working with steel girders of a standardized pattern. On a different scale, each designer works with the same instincts and intelligence.

The machine age, that is to say, has brought into prominence an artist of a new type—or rather, it has isolated or made distinct an essential type of artist, the artist of abstract form. It was the same type of artist who built the Parthenon or designed a Greek vase, who built Chartres Cathedral or designed the coffeepot illustrated in Figure 42. If modern machine-made art suffers or fails, it is because the existence of this type of artist is not recognized by our educational system, nor by our industrial system. For the most part he is unconscious of his own existence. But in every complex modern industry, where labor is subdivided between various machines and processes, there must be first a designer to divide the required object into its constructive components. I put it this way round, because more often than not this is how he works. But when the right order prevails, then this designer will construct with

the components which each machine is capable of delivering; and will design machines to deliver components which he requires for his construction. For the work of art in the machine age is a construction; it is built like the Parthenon.

It follows, I think, that we must enlarge our concept of the work of art. The things we use in modern life are infinitely more numerous and more complex than ever before. When such things come into our life—such things as typewriters, petrol pumps, refrigerators, vacuum cleaners —our first impulse is to put them in a category altogether distinct from objects such as dishes and candlesticks, which we have grown accustomed to regard as fit objects for aesthetic form. But once these objects too were intruders into a world of simpler utensils, or of no utensils at all. And just as they have been assimilated to the traditions of good form and design, so these new and complicated tools and utensils must equally be regarded as material for the application of the principles of design. For those principles are ubiquitous; there is absolutely nothing we make and use which cannot submit to the discipline of form, and its accompanying grace or harmony.

PART 3

COLOR AND ORNAMENT

If the general plan is more or less conformable to a geometric idea the mind might be tempted to apprehend it merely as a case of a generalization (as it apprehends a diagram in Euclid); but the perpetual slight variations of surface keep the mind and attention fixed in the world of sensation. We are, as it were, forced to abandon our intellectual in favour of our sensual logic: I think we can indeed note from our personal experience that the majority of people find the intellectual apprehension of things easier, and always take any excuse to slip away from sensual into logical apprehensions.—ROGER FRY: *Last Lectures*

catching the eye

As already indicated in Part 1, ornament is fundamentally
a psychological necessity. Any adequate treatment of this
aspect of the question would take us rather deeply into
the psychology of the perception of space; and the facts
of vision, as William James observed long ago, form a
jungle of intricacy. That intricacy is mainly due to the neces-
sity of constructing a three-dimensional space—or rather,
to the difficulty of explaining how we do in practice con-
struct such a spatial perception. Spatial order is an abstract
term. It is the end result of numerous sensations of the
surface of the skin, the retina, and the joints of our bodies.
The various sense-spaces are in the first instance inco-

herent. Our space perception, that is to say, had to be educated, and according to James, this education consists largely of two processes—reducing the various sense-feelings to a common *measure,* and *adding them together* into the single all-including space of the real world. Both the measuring and the adding are performed by the aid of *things,* things whose *real* size and shape we can feel, and from which we can infer our space-sensations in general. But for the moment we are concerned only with the much simpler problem of the perception of two-dimensional planes—the perception of extension, that is to say. Normally this is the function of the eye, but on account of its physical construction it is very difficult for the eye to "take in" a plane surface. William James describes its activity very clearly: "On the retina the fovea and the yellow spot about it form a focus of exquisite sensibility, towards which every impression falling on an outlying portion of the field is moved by an instinctive action of the muscles of the eyeball. Few persons, until their attention is called to the fact, are aware how almost impossible it is to keep a conspicuous visible object in the margin of the field of view. The moment volition is relaxed we find that, without knowing it, our eyes have turned so as to bring it to the centre. This is why most persons are unable to keep the eyes steadily converged upon a point in space with nothing in it. The objects against the walls of the room invincibly attract the fovea to themselves. *If we contemplate a blank wall or sheet of paper, we always observe in a moment that we are directly looking at some speck upon it which, unnoticed at first, ended by 'catching our eye.'* " *

This last sentence, which I have italicized, expresses

* *The Principles of Psychology,* Vol. II, pp. 161–2 (edn. 1891).

clearly enough what I have called the psychological neces-
sity of ornament. But it will be observed that the eye acts in
this instinctive way *the moment volition is relaxed*, and the
first question to raise is whether *aesthetic* perception is an
unvolitional act. It is possible to maintain that when we
look at an object with the intention of appreciating its form
—that is to say, its extension in space—we deliberately
avoid such a wandering of attention. But actually this is not
the case, because most works of art do not admit of any
possible fixed focus—they deliberately invite a wandering
eye.* A work of art which in no way invited a focus would
have to be perfect and spotless in texture, absolutely sym-
metrical in shape, and suspended in a vacuum of even
light. It might as well not exist at all. We may conclude,
therefore, that in all works of art we have to contend with
the roving eye; and if the work of art is an abstract work
of art, that is to say, a work which the eye does not read
like a book for its literary content, its pictorial expression
of ideas and sentiments—we must provide the eye with
specks on the surface, with points of rest or attachment.

Actually, as James so acutely observes, the texture of
the material we are looking at will in most cases provide
such specks. In looking at a pot, the eye will unconsciously
fix on some highlight or intensity of color in the glaze. Per-
haps the eye is "happier" if one such spot is so definite
that no possibility of indecision in the act of focusing is pos-
sible. But obviously if such a spot is so definite, or so
eccentric, that it is difficult for the eye to "take in" both the
spot as a focusing point and the pot as a whole, then a
physical strain arises which will interfere with our aesthetic

* I have dealt with this question as it affects certain types of contemporary painting
in *Art Now* (2nd ed., Pitman, 1960), pp. 77-80. For a more recent discussion of these
problems, including the bearing on them of the "Gestalt" theory of perception, see
Education Through Art (Pantheon, 1958), Chap. II, "On Perception and Imagination."

pleasure. From which simple case we may deduce the golden rule of all ornament: *ornament should emphasize form.*

That the explanation of the necessity of ornament in terms of optical psychology may not exhaust the complexity of the problem is a possibility of which I am well aware. Certain historical types of ornament, such as Celtic ornament, seem so complicated in their linear rhythms, so agitated and so crowded, that a profounder explanation seems necessary. Purely physio-psychological needs would be satisfied with so much less; and yet the something more has no literary or anecdotal function. It tells no story; it merely fills a space in the most complicated way possible. Professor Worringer has offered an explanation, which sees in such complexity a reflection of the spiritual or religious mentality of the Northern races at this period of their development, and such would seem to be the most reasonable hypothesis.*

the origins of ornament

Whatever physiological and psychological necessities may exist for ornament, its actual origin and development can be explained in simple materialistic terms. It is true that for the sake of simplicity we have to neglect certain anomalous types of ornament belonging to the earliest phase of human civilization—the palaeolithic period. To this period belong a few objects mostly of bone, and for the most part apparently objects of personal adornment, which bear incised lines, chevrons, and curves, for which no obvious

* *Form in Gothic*, by Wilhelm Worringer (Transatlantic, 1957).

explanation exists. A utilitarian explanation seems out of question, and the suggestion that they are primitive tallies for counting does not carry much conviction; some of the forms of decoration are too complicated for such a purpose. Historically, therefore, one must begin with a psychological explanation.* But when we pass to a later stage in prehistory, to the neolithic age, the evidence is much more plentiful and much less equivocal. We are able to conclude without any doubt that, whatever the purpose and appeal of the ornament, its forms arose in, and were determined by, the material and the process of manufacture. We may still assume a previous psychological necessity; but the fulfillment of this necessity was inevitable. It was inherent in the material or in the constructive form assumed by the material.

Ornament, in short, may be divided according to its origins into two types: (1) structural, and (2) applied.

Structural ornament may further be distinguished as (a) fortuitous, and (b) factitious. It is fortuitous when some natural property of the material has in itself an ornamental effect, as the grain in wood, or the metallic oxides in clay which form colored patches when fired in the kiln. Color itself is originally fortuitous.

* The best treatment of the decoration and its aesthetic significance in the palaeolithic period known to me is in G. H. Luquet's *L'art et la religion des hommes fossiles* (Paris, 1926). The following paragraph is a summary of the author's conclusions: "Pour conclure sur cette ornementique primitive, elle nous semble le résultat d'une collaboration et d'une action réciproques des bijoux et des instruments. La conception sur laquelle reposent les bijoux primitifs, qu'un objet peut être rendu plus beau par des additions sans utilité pratique, aurait été étendue du corps humain aux objets d'usage; en sens inverse, le caractère agréable à l'œil constaté dans des incisions faites sur des objets d'usage pour des fins utilitaires aurait amené à les répéter non seulement sur ces mêmes objets avec une intention ornementale, mais aussi sur les bijoux. Dans un cas comme dans l'autre, nous croyons constater dès le début de l'art préhistorique l'existence et la recherche d'un plaisir produit par certaines impressions sensorielles (ici visuelles) indépendamment de toute autre préoccupation, ce qui est l'essence même du sentiment esthétique et du sentiment artistique." (p. 133)

Ornament is factitious when it arises out of the actual process of working the material, as the ridges made in a clay vessel when it is thrown on the wheel, or the check effect of weaving together two strands of wool, leather, or osier which vary naturally in color.

When ornament begins to play a large part in human economy, that is to say, in the neolithic period, most, if not all types, are either fortuitous or factitious in origin; that is to say, they are imitations or developments of natural qualities in the material or of accidental effects due to working the material. Then in the course of time the origin of the ornament is forgotten, and it develops into geometric and abstract patterns of the utmost freedom. Even when we reach the stage of applied naturalistic ornament, there is a tendency for patterns to lose their original naturalistic or illustrative intention, and, through a gradual process of slurring, to develop into geometric and abstract patterns. The accompanying illustration shows two stages in such a process of development.

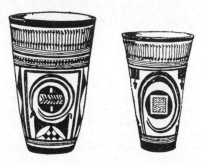

Two jars from Susa, showing geometricized animals—long-necked birds, and goats whose horns become circles and ellipses. From Manuel d'Arché-ologie Orientale, *by Dr. G. Contenau (Editions Auguste Picard, Paris).*

Why should such a development take place? It is possible to see in it nothing but the incredible carelessness and

inefficiency of the worker; it is possible also to suggest that an unconscious judgment is at work, which finds abstract ornament more appropriate on an object of daily use.

I have compressed into this section questions which can be adequately dealt with only in long and elaborately illustrated volumes. My purpose has been to suggest that there is good historical precedent for two "laws" of ornament which we shall find fulfilled by the products of the machine age no less than of the stone age:

I. Appropriate ornament arises naturally and inevitably from the physical nature of a material and the processes of working that material.

II. Ornament betrays an inherent tendency toward abstraction.*

types of applied ornament

Any stylistic analysis of types of ornament in the past can only be schematic—that is to say, it cannot be based on any exact evolutionary conception. That evolution is, if continuous, of a cyclical nature; we cannot determine for certain which style is historically the first type—geometric merges into "stylized" ornament, which merges into naturalistic ornament, which merges again into geometric, and thus completes the circle. But the following analysis will be found to include all possible types.

* Or, as it might be formulated: "Ornament, if left to itself, tends to become abstract, because the psychological necessities are most appropriately and most economically supplied by abstract ornament."

geometric

Ornament composed of straight lines, curves, dots, etc., to which no pictorial significance can be assigned. It is possible that certain marks and patterns (the swastika, for example) may have a symbolic significance, but as ornament such patterns are still to be regarded as geometric.

stylized

This term is used for those types of ornament which while based on naturalistic objects (animals, plants, etc.) yet depart from the exact representation of such objects in the interests of linear rhythm, simplification, and formal significance generally.

organic or naturalistic

This type of ornament is pictorial in intention, and may for convenience be subdivided into the following species:

 i. human figures and "genre" subjects;
 ii. animal subjects;
 iii. plants and flowers;
 iv. landscapes.

These are the generic types of ornament, but two further types, which are varieties or combinations of these primary types, may be noted:

pattern

I reserve this word for ornament which is repeated "all over" an object. It may be organic, stylized, or geometric, but it takes a unit of one of these types of ornament and reduplicates it in a series coextensive with the area to be decorated.

By plastic ornament, I mean ornament which is not so much "applied" to the object, but is the object itself. The object, that is to say, is molded into a shape which has a decorative function altogether distinct from the utilitarian function of the object. Examples are pottery and metal vessels in the form of human beings or animals. Röntgen, the famous Dutch pianist, was presented with a house in the shape of a grand piano (lid up). Such ornament tends to fall into the following dilemma, so far as our consideration of it is concerned. If it is adequate as a representation of a human being or animal, then it becomes an example of what we have called humanistic art; its design is no longer significant for its function, for obviously an animal's form was not designed to fulfill the functions of a jug, nor does a jug suggest the form of an animal. In the case of the house in the shape of a piano, somewhere, we may be sure, there was a loss of space, or a waste of material; it therefore fails as architecture. The magnificent zoomorphic vessels of the Middle Ages are perfect as plastic works of art (sculpture), but they have obvious limitations as functional vessels.*

ornament in relation to form

Ornament, of whatever type, should be appropriate to the form of the object it decorates. This is an obvious consideration, but it is often neglected in modern industrial

* This classification of types of ornament was suggested to me by Dr. Karl With's arrangement of the Kunstgewerbe Museum at Cologne.

art. There are at least three considerations to be borne in mind:

Size. The scale of the ornament should bear a strict relationship to the size of the object on which it appears. It would be a mistake, for example, to apply the same standard ornament to a coffee cup and a breakfast cup.

Shape. This is the most difficult relationship to realize, but perhaps the most important. Let us take the test case of pottery again. A pot has a certain outline (*galbe*) and a certain mass. Any ornament it bears will be conscious of both these aspects of the pot. It will "echo" in some way the outline of the pot, repeat its linear rhythm, continue it and multiply it infinitely. Similarly, it will emphasize the mass of the pot, underline its swell and weight, lift and lower the movement of its plastic form. In more complicated cases, the ornament will play across outline and mass, as a counterpoint to the form; but this is perhaps a subtlety of which only the individual potter is capable, and then only the potter of genius.

Association. This is a question of common sense, and applies mainly to pictorial ornament. Floral ornament, for example, is appropriately associated with textiles and with table services; there is no particular reason why it should be associated with metal stoves or with lavatory fittings. These three considerations lead us to formulate a third law of ornament, already foreshadowed in Part 1. It might be most briefly stated as:

Ornament must fit form and function.

machine ornament

We must now consider how these laws of ornament affect machine-made products. Referring to the list of types of ornament given above, I think it will be obvious that we must rule out as inappropriate to machine methods of production the whole of the *organic* and *plastic* types of ornament. The success of this type of ornament depends on rendering the vitality of living things—plants and animals—and this quality can be rendered only by the subtlest and most sensitive means, which will always be human means. Modern methods of mechanical reproduction are often very exact, and there may be a limited scope for naturalistic decoration in machine production where an exact photographic process can be employed—chocolate boxes, for example. But in most cases such processes will not be possible, nor desirable. The same is not true of the *stylized* type of ornament. While the best types of stylization—such as we get in early Chinese bronzes, Persian pottery, Gothic stained glass, etc.—depend for their vitality on "the human touch"—the fact that it is the individual creation of a craftsman—yet there is no doubt that a stylized form lends itself to reproduction infinitely better than naturalistic forms. Stylization always implies simplification, even standardization; a stylized animal is not a unique animal, but the type of a species. And stylized ornament has been reproduced quite often in the pre-machine ages—in bronze castings, for example. With the infinitely more precise methods of reproduction now avail-

able in all materials, a very wide use of stylized ornament becomes possible, and is, in fact, established. Modern carpets and textiles generally reproduce such ornament.

But the most appropriate type of ornament for machine production is undoubtedly mechanical ornament—that is to say, the *geometric* type of ornament. Here again it is possible to say that the appeal of geometric ornament in neolithic or Celtic art is due to the individual variation and sensibility of its execution. And for the products of these periods, that is true; machine-made ornament on a neolithic pot would be absurd (though incidentally at a very early stage the potter began to use a wooden stamp, and even a roulette, to impress his ornament). But the formal values of machine-made objects, which we have already elucidated, are quite distinct from the formal values of hand-made objects; and to match the virtues of precision and abstraction in the form of machine-made objects, we need precision and abstraction in the ornament. And these qualities the machine can provide. The impression or incision of lines, hachures, punches—any repeated or continuous pattern—is an appropriate function of the machine.

In this way the machine can meet the pyschological need for ornament; it can fill the blank space, give the eye a point of rest. If it cannot reproduce the variety and vitality of all types of ornament, it can give precision, cleanness, and appropriateness. But let us for the moment admit that on the balance, certain aesthetic values are lost—that nothing, shall we say, in modern industrial pottery can compensate us for the loss of the color and individuality of the peasant pottery of the seventeenth and eighteenth centuries. Apart from the consideration that we live in the twentieth century, and that in the mere passage of time the traditions of two hundred years ago are now lost, we

must remember that the creative faculties of man are constant. From time to time they disappear underground, and re-emerge to flow in different channels. New arts arise to take the place of old arts—the novel replaces the drama, the cinema the music hall; and if we have lost the peasant craftsman, who was not appreciated in his day, we can find a very good substitute in the modern painter. If it is objected that the modern painter is not quite the same thing, that his naïveté is conscious and sophisticated, then it must be pointed out that the aesthete's admiration for peasant pottery is equally self-conscious and sophisticated, and bears no direct and organic relation to the production of that pottery. All attempts to revive such types of art, lacking economic and practical justification, end in artificiality and crankiness. The economic law is absolute, and healthy; it compels the human spirit to adapt itself to new conditions, and to be ever creating new forms. It is only when sentimentality and a nostalgia for the past are allowed to prevail, that these forms cease to evolve in conformity with aesthetic values.

PART 4

ART EDUCATION

IN THE INDUSTRIAL AGE

There is every reason why a child should not be allowed to work for commercial profit or for the support of its parents at the expense of its own future; but there is no reason whatever why a child should not do some work for its own sake and that of the community if it can be shown that both it and the community will be the better for it. Productive work for children has the advantage that its discipline is the discipline of impersonal necessity. The eagerness of children in our industrial districts to escape from school to the factory is not caused by lighter tasks or shorter hours in the factory, not altogether by the temptation of wages, nor even by the desire for novelty, but by the dignity of adult work, the exchange of the humiliating liability to personal assault from the lawless schoolmaster, from which grown-ups are free, for the stern but entirely dignified pressure of necessity to which all flesh is subject.—BERNARD SHAW: *Preface to Misalliance*

The common defense of the industrialist, when accused of indifference to aesthetic values, is a plea of justification. "From a highbrow artistic point of view," he will say, "my products may be bad; but they are what the public wants, and if I were to adopt your good designs I should lose trade. If you will first educate the public, then I will produce articles of good design."

It is an argument used in many other spheres—in the theater and the cinema, for example—and one has good cause to controvert it. Indeed, one might say that it is disproved whenever the public is by some chance offered an article of good design. For the public is much more

docile than this argument represents—it is much too docile. Actually the villain of the piece is the liaison officer between the producer and the public. He is usually a middleman of some kind, a commercial traveler or more likely the sales manager of a retail business. It is this individual who decides that the public will not buy. To some extent he may be justified by his knowledge of public taste, but more often I suspect he is influenced by his own taste. He, Mr. Jones, the head salesman of Smith's Universal Stores, is a middle-middle-class man with a nice little home in the suburbs, and every suggestion that comes before him he mentally compares with the comforts of that nice little home. He does not see how "this modern stuff" would fit into that conventional background—a background into which have drifted residues of family possessions, wedding presents, and all the flotsam of the hire-purchase system; a concentrated collection of representative specimens of the industrial art of the last fifty years. Though Mr. Jones may be a very representative figure, he by no means represents the whole of our social structure, and both above him and below him in the social scale are millions of people not burdened with the same prejudices or possessions, even willing to scrap the old for the new. But because Mr. Jones stands between them and the producer, they must do without the simple things of modern taste, and accept the nearest compromise that the retail system offers them.

Nevertheless, the problem of education exists. Mr. Jones is representative of a substantial section of the community; and a still larger section is simply uneducated, without even bad taste, merely indifferent to their surroundings. The production of well-designed objects of daily use would undoubtedly be stimulated by a higher level of public

taste, by an increased sensibility to the elements of design. That is one side of the problem, and certainly an important one: we will call it *the education of the consumer in aesthetic appreciation.*

The other side of the problem is more obvious; we will call it *the education of the producer in aesthetic design.*

Let us first see how the problem is dealt with in our present educational system. I refer more particularly to the English system, but my general conclusions certainly hold good for the rest of Great Britain and for modern industrial society as a whole. Our educational system is fourfold: primary, secondary, technical, and university. The technical school is concerned specially with the education of the producer, but we shall see presently to what extent that education overlaps with the education of the consumer, which is the concern of the other three grades of schooling. We may say at once, without any fear of contradiction, that the education of the potential consumer in aesthetic appreciation is entirely unsystematic, uncoordinated as between the three grades of education, and almost completely nonexistent in two of them.

It is possible to maintain (as does Mr. Clive Bell) that the appreciation of art is a special gift, that only those endowed with a special sensibility are capable of reacting to the aesthetic qualities in a work of art. It is true that some people are born blind, others deaf or dumb; but wherever the senses of an individual function free from inherited or acquired disease, it is possible to educate and refine these senses. *Aesthetic education is nothing more or less than the education of the senses.* The senses normally and naturally react—the senses of sight, sound, and touch. Once the individual becomes aware of these reactions, and learns or is taught to compare and estimate his reactions,

he has begun the process of aesthetic education. The degree or depth of that education will be affected by other factors—by the individual's social background and still more by his intellectual background; but the primary nature of aesthetic appreciation is purely sensual, and a natural biological function. The process of aesthetic creation, *the invention of design,* is a different process; it originates in the mind, and is directed outward to objective materials by the power of the will; and only in exceptional individuals does the capacity for such an intellectual exercise exist.

Education from beginning to end should be the education of the whole man. The great artist is never a specialist. Nevertheless, the discovery of talent should be one of the earliest stages in education; that is to say, it should be a function of the elementary schools. It may be objected that at the elementary stage, the intellect and will of the child are in a very rudimentary state. If one seeks to assess these qualities by the spontaneity of their achievements, the objection must be admitted; but I prefer to regard both intellect and will as inherent potentialities, present in the individual from birth. Experience clothes these potentialities in garments of ideas and designs; force traces its pattern in experience. Education is experience made conscious, and the earliest stages of education are probably the most intense, the most effective. From this point of view the experiments initiated by the late Marion Richardson in the elementary schools of the London County Council were of the greatest significance. Miss Richardson invented a technique for discovering innate talent. She showed that the youngest children, if aided by mechanical and schematic means, became supreme inventors of pattern. By such devices as the folding of paper to make

a scaffolding of creases, the repetition and inversion of simple integers (figures, letters, etc.), an *inventive* activity can be induced in the child's mind; this activity can then be extended to the harmonizing of colors, and finally produce a design of high aesthetic value. The method is still in its experimental stages, though the proofs, so far as it has gone, are not to be questioned. What still remains to be determined is to what extent the inventive activity will remain when the mechanical aids are dispensed with, and the child is left to its own inherent energy of will. Probably only a small minority will retain the faculty for invention: but this is the minority to be trained as producers of aesthetic design.

The other aspect of aesthetic education, which should begin at the primary stage, is completely neglected by our system. This is what I have called the education of the senses, and by this I mean literally the training of the senses of touch, sight, and hearing. For the plastic arts the senses of touch and sight are the important ones. Some indication of a possible method is given by Professor Moholy-Nagy in his book *The New Vision* (London, Faber & Faber, 1939), which is based on his lectures at the Bauhaus in Weimar and Dessau, Germany—the greatest experiment in aesthetic education yet undertaken. Tactile exercises, for example, were devised, for which various "tables" of material were used—a table of different textile threads, a table of screws for pressure and vibration sensations, a table of nails for pricking sensations, a table of various materials to show contrasts between soft and hard, smooth and rough. More complicated tables combined all these materials of sensation, until the student could make tactile exercises on them very much as a music student makes exercises of sound on a piano. From such an

elementary basis, the physical properties of materials are studied in relation to their structure, texture, surface aspect, and mass arrangement. Exercises are given to show the different effect of different tools on the same material, and so gradually the student is led to an awareness of those qualities which enter into the aesthetic relations between form and material.

How far the appreciation of abstract formal values can be taught to the child in the primary school has yet to be determined. No one in this country, as far as I am aware, has ever made any experiments. The right method, I imagine, lies through the analysis of natural forms. "All technical forms," writes Raoul Francé,* "can be deduced from forms in nature. The laws of least resistance and of economy of effort make it inevitable that similar activities shall always lead to similar forms. So man can master the powers of nature in another and quite different way from what he has done hitherto. If he but applies all the principles that the organism has adopted in its striving toward useful ends, he will find here enough employment for all his capital, strength, and talent for centuries to come. Every bush, every tree, can instruct him, advise him, and show him inventions, apparatuses, technical appliances without number."

The close correspondence between harmony in numerical proportions, that is to say, abstract harmony or form, and harmony in natural forms, should enable the teacher to devise object lessons simple enough for a child's apprehension (he might compare, for example, the form of a pear with that of an eighteenth-century coffeepot, a leaf with a butter knife, a flower-stem with an architectural column; show the structural purpose underlying each form,

* *Die Pflanze als Erfinder* (Stuttgart, 1920). Quoted by Moholy-Nagy, op. cit., p. 53.

and then show how the form corresponds to number—the possibilities are infinite. Naturally the teacher must know something of biology as well as of art; but if he knows the one subject thoroughly, he *inevitably* knows the other). This aspect of the problem must await more extensive treatment; I mention it here merely as an indication of the possible scope of the primary stage in education for aesthetic appreciation.

The fact that more is done toward education in aesthetic appreciation at the secondary school stage merely complicates the problem. For what is done is based on a complete confusion of values. There is no attempt to distinguish invention from appreciation, or to separate the functions of the producer and consumer in art. Art is indeed recognized as a productive activity, but what kind of art? For at this stage all the confusion between the fine and applied arts enters into the educational system, and art in its functional aspects—that is to say, the typical art of the machine age—is relegated to the technical school. Art in the secondary school is essentially a matter of drawing, modeling, and painting, and, in a few advanced cases, of a sketchy outline of the history of the Fine Arts. In other words, to put the matter bluntly, at this stage the potential consumer of art, as well as the potential artist, is completely divorced from the significant art of his age. That art, as I have already shown, is essentially an abstract art, quite distinct from the humanistic art of the Renaissance. Humanistic art is a great heritage, and a knowledge and appreciation of it should form an integral part of any educational system; but what we do at present is to teach, not only potential artists, but the potential citizens who are to live in a modern machine age, the practice and technique of an individualist art which not one boy in a million will ever

practice with profit or distinction. We might as well teach potential motor mechanics to drive horses.

To effect the necessary change, our present conception of the art master in the secondary school has to be radically altered. I mean no disrespect to the existing type of art master. Trained as a painter at the Royal Academy, the Royal College, the Slade School, or some other such institution, he is often a talented pasticheur in the humanistic tradition of art—perhaps not talented enough to make a living by painting in a shrinking market for such art (or otherwise he would not be a teacher), but sensitive to aesthetic values and generally a focus of culture in an atmosphere of sport and examination lists. In rare cases he may have a perception of aesthetic values which his official curriculum does not recognize, but that is exceptional. Generally he will attempt to teach his classes to draw reasonably accurately from life, and to avoid the harsher discords of color with which their daily lives are poisoned. He does his best in a world which despises him, and under a system for whose organization he is not responsible.

In *The Grass Roots of Art* * I have suggested that if a clear distinction could be made between humanistic art and machine art, then the place which humanistic art should occupy in general education would become clear. Admittedly we cannot base a civilization on rationality or functionalism alone. "The foundations of a civilization rest not in the mind but in the senses, and unless we can use the senses, educate the senses, we shall never have the biological conditions for human survival, let alone human progress."

I then went on in this book to suggest that we should

* Rev. ed., Wittenborn, 1955.

look forward to some division of our human and social activities which would ensure a due proportion of time devoted to manual craftsmanship. But I pointed out that it would be impracticable to achieve this by any artificial interference with industrial development: "We cannot, at this stage of development, oppose the machine. We must let it rip, and with confidence. Egyptian art proves that its spirit of objective rationality is capable of the most magnificent and awe-inspiring achievements. We can already see its potentialities around us, in the functional buildings which have already been erected in this country and elsewhere, and in some of the products of machine industry. But do not let us make the mistake of assuming that a civilization can be based on rationality or functionalism alone. The foundations of a civilization rest not in the mind but in the senses, and unless we can use the senses, we shall never have the biological conditions for human survival, let alone human progress.

"We must look forward, therefore, to some division of our human and social activities which will ensure a due proportion of time devoted to manual craftsmanship. It would be quite impracticable to achieve this by any artificial interference with industrial development. We cannot select several industries—say furniture and pottery—and reserve these for handicraft. Such vertical rifts in the industrial system would lead to economic anomalies and social inequalities. They would divide the industrial world into a technological priesthood and a lower order of handicraftsmen. That solution might be possible under some system of centralized planning, but I think we can dismiss it as undesirable, and as only partial in its effects. But there is another possibility, and this is to make the division horizontal, affecting every industry and every individual,

but only up to a certain point. In other words, let every individual serve an apprenticeship in handicrafts. I go further: I would say that handicraft, or rather, since this word has too limited an application, that creative arts of every kind should be made the basis of our educational system. If, between the ages of five and fifteen, we could give all our children a training of the senses through the constructive shaping of materials—if we could accustom their hands and eyes, indeed all their instruments of sensation, to a creative communion with sounds and colours, textures and consistencies, a communion with nature in all its substantial variety, then we need not fear the fate of those children in a wholly-mechanized world. They would carry within their minds, within their bodies, the natural antidote to objective rationality, a spontaneous overflow of creative energies into their house of leisure."

Such a primary education of the senses is suitable to the primary stage of education. It would extend into the second stage of education, but during the secondary stage, on the basis of this apprenticeship in handicraft, the pupil would begin to specialize in some form of technical education (and from this point of view "grammar" is a technical specialty). Specialization cannot be avoided, for it has its basis in variations of human dispositions and aptitude. But the purpose of education should be to mitigate rather than exploit the narrow bias of such a misfortune, and make men various, virtuous, and whole.

The relation of the technical school to the secondary school is a question which I cannot deal with now; * but as all careers are technical, it would seem to follow that the secondary stage of education should consist of a basic

* I am ignoring the present indefensible division of secondary education into Grammar, Technical, and Modern Schools.

level of aesthetic education, with technical extensions in every vocational direction; and my own personal opinion is that this should still be the principle of university education, so that in every sphere we aim to produce a whole man, and not an uncultured specialist.

At the technical stage of education, as it exists at present, the force of circumstances has brought about some adaptation of the system. The art schools which were founded a hundred years ago with a supply of plaster casts from the antique have in many cases been driven into realistic relationship with local industries.

The change of attitude is well illustrated in the gradual revision of the art examinations conducted by the Ministry of Education. In 1913 a new system was introduced which included Drawing, Painting, Modeling, Pictorial Design, and Industrial Design for (i) Handicrafts and (ii) Manufactures. In 1946 the system was reorganized and the examinations renamed. A Departmental Committee on Art Examinations which issued its Report in 1948, described the position in 1946 as follows:

"The 1913 system remained substantially intact until 1946. . . . The majority of the candidates were fulltime students of schools of art who had continued their secondary education up to the age of sixteen. The Drawing Examination, which was usually taken at the end of the second year of fulltime art study, consisted of tests in six subjects, namely, Drawing from Life, Drawing and Painting from Memory and Knowledge of Anatomy, Architecture, Drawing from the Cast and Perspective. Courses normally embraced a wider field of study, and accordingly the reorganized examination, which was renamed the Intermediate Examination in Arts and Crafts, provided tests in a wider range of subjects, namely, the first four men-

tioned above, together with Drawing the Figure in Costume, Creative Design for a Craft, Modelling and General Knowledge."

In their Report the 1948 Committee recognize that there are now two main careers for the students who take the Ministry's art examinations, teaching on the one hand and designing for industry and commerce on the other. It is not their business, they say, to discuss the teaching of particular subjects, nor, "since our business is with examinations, shall we be expected to attempt to expound a philosophy of art education. We content ourselves with the statement that the schools must encourage and develop in their students sensitivity to aesthetic values and the ability to discriminate between the good and the mediocre, and to select the best. For these we consider that the right nurture is a sound basic art education."

The Committee recognize, further, that "it is an advantage that would-be teachers and would-be designers should mix." There should therefore be a common course for all students in art schools, lasting at least for two years of full-time study, with an Intermediate Examination at the end of it.

After that, some degree of specialization must take place. Students intending to enter industry or commerce will concentrate on a special subject or subjects, but it is recommended that students intending to be teachers should always take courses broad enough to enable them to undertake effectively the teaching of art and crafts, in schools of general education. As for students intending to enter industry, it is recognized that "industrial or commercial experience is necessary in addition to art school education . . . and we do not expect the schools to produce designers who will immediately be productive in the

business sense without initiation into the requirements of the branch of business concerned." The Committee also emphasize that the links between the art schools and industry and commerce can be strengthened at the teacher level, at the student level and in the administration of the examinations. "Interchange between teaching and industry is essential."

From the point of view advocated in this book twenty years ago, and advocated for a still longer period by such bodies as the Design and Industries Association, all this shows a wonderful advance in the understanding of the relations between art, education, and industry. The chief obstruction to further advance is now to be looked for in the industrial system rather than in the educational system. The modern industrial system in England is still not disposed to regard the technical schools (and particularly those which claim to teach industrial design) as a part of their economic organization. For this prejudice there is some justification, for the art schools in general are not equipped with plant and machinery to enable their students to become "effective practitioners" of the more advanced industrial processes. In this sense our schools are far behind such a prototype as the Bauhaus, or some of the schools established on that model in the United States.

Art itself, it will be seen from the Report of the Committee on Examinations, is still regarded as a profession in itself. The four main fields for the future employment of art students are given as (a) Painting and Sculpture; (b) Design for Illustration and Advertising, including Display; (c) Design for Industry; and (d) Teaching. An "art school," in the official sense of the word, should prepare the student for all these vocations, and it is assumed that all these vocations are arts. But in the popular sense of the word,

and in the sense of the word as understood by industrialists, an art school is a place where painting and sculpture is taught, and where industrial design is not merely segregated, but barely tolerated. Admittedly the official policy is to get rid of this dichotomy, and to regard the "professional" artist (i.e. the painter or sculptor) as merely one kind of specialist equal in status to the industrial or commercial artist. But to be honest we must admit that we are thus using the words "art" and "artist" ambiguously. Art is still a self-conscious, humanistic study, far removed from the humbler if more remunerative vocations of modern society. This fundamental prejudice is still perpetuated in all branches of our educational system. Art is regarded as something distinct from the process of machine production, something which must be taught as a distinct (though "basic") subject, afterward to be introduced into the processes of industry. But obviously, the factory itself must be the school of design, or the school of design must become in some real sense a factory. The whole notion of the artist as an intruder in the factory must be eradicated. If at the same time we abolish the notion of the artist as a separate entity, a separate individual, so much the better. The true kind of artist, the only kind of artist we want apart from the humanistic artist (painters of landscapes, portraits, modelers of war memorials, etc.), is merely the workman with the best aptitude for design. That has always been clearly recognized in one industry—building, where we call the designer by the special name of *architect* (i.e. literally, master builder, leading craftsman). What we need is the recognition of the architect in every industry. Let us take as an example once again the simple case of the potter. The child who in his elementary school at Stoke or Burslem shows a talent for inventive design should not on

that account be henceforth isolated and trained as if he were another Raphael; the chances are a million to one against his being a genius of that kind. He is just a good designer, and he should become a potter like his fellows. When he reaches the technical stage of education, he should still be trained as a potter. Good design, as we have seen, is governed by considerations of material, working, and function. All these are part of the technical process of potting. No teacher of art, admirable as he may be as a painter of landscapes or portraits, can teach the young potter anything essential to the mastering of design in the material of his craft. Only the experienced potter can teach him anything of value. There remains the question of ornament; people must have some of their pots decorated—penny plain and twopenny colored. But here again I have contended that the appropriate decoration is to be found in materials and technical processes. It was not an artist who discovered any of the forms of decoration typical of pottery before the middle of the eighteenth century, nor even of the best types of decoration typical of any pottery since that time; in every case it was the potter, working with the materials of his craft, and the tools of his craft. When the "pure" artist is brought in, then either he merely uses the surface of the pot as he would use the surface of canvas, and we judge the result as a painting and not as a pot; or he produces some abomination which has no relevance to the material or function of the pot. What is true for the simple industry of pottery is equally true of all industrial production of objects of use—of furniture, metalwork, and textiles. Indeed, such is the paradox of the present position, that it is in industries where the artist as such never enters—the electrical industries, for example—that we find the best formal designs.

Let us by all means continue to educate selected individuals to be painters of landscapes or portraits, modelers of war memorials, etc.—though even here I believe by far the best system would be some system of apprenticeship in the studios of practicing artists; but let all other forms of art instruction be assimilated to the *Fachschule,* or, where these do not exist, to the factories themselves. The only alternative is to convert the schools into factories—which is exactly what the Bauhaus was in Germany: a school with the complete productive capacities of the factory, an industrial system in miniature.

I have been able to give, in these few paragraphs, only a brief survey of the problems connected with art education in an industrial age. Education, as I have tried to show in another book (*Education Through Art*), must itself be fundamentally reformed.* But in the end we shall find that the fundamental factor in all these problems is a philosophy of life. The problem of good and bad art, of a right and wrong system of education, of a just and an unjust social structure, is in the end one and the same problem.

* I have given further consideration to these problems in *The Grass Roots of Art* (rev. ed., Wittenborn, 1955) and in *Education for Peace* (London and New York, 1950).

ILLUSTRATIONS

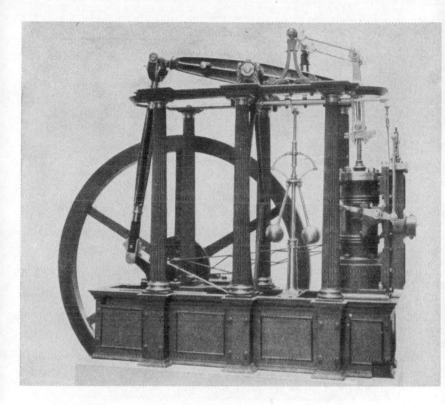

1 : A refined example of taste in the early machine age—a factory beam engine of about 1830. The elegance of the classical columns and pedestals, and the absurd little cast-iron scrolls above the cornice, make a strange disharmony with the purely functional parts of the engine. It is difficult to realize now that such an object was designed in all seriousness with no sense of incongruity; but that sense of incongruity is due only to the fact that the engine has long since emancipated itself from such meaningless ornament. Most people find nothing incongruous in many examples of modern architecture (such as Selfridge's Stores in London) which are just such illogical amalgams of function and ornament. *The Science Museum, London*

2 : "Applied" art. This rose-engine—a lathe for turning rose-pattern engraving on metal—precedes the industrial age (it was made in Germany about 1750); but it shows that already a division existed between form and decoration; and that machinery was thought of as something to be as far as possible concealed. It differs from a similar object a hundred years later in that the ornament which smothers the machinery is original contemporary ornament; but that does not justify its application. *The Science Museum, London*

right

3 : Compare with the previous figure this almost contemporary spinning wheel. No attempt is made to disguise the functional machinery, but nevertheless the best formal sensibility of the period is embodied in its design. What little ornament there is is discreet, confined to the emphasis of joints and terminals, and completely subservient to the general structure. *Victoria and Albert Museum*

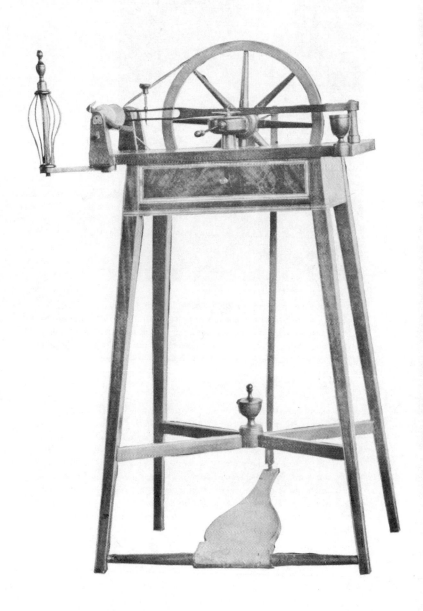

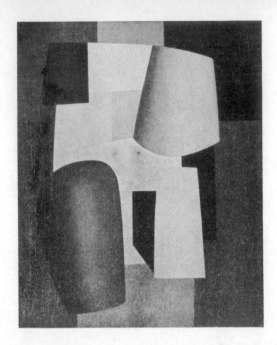

4 : An "abstract" painting by Jean Hélion. 1934. Pure design without any functional intention, and without any representational aim vis-à-vis "nature" or the world of fortuitous events external to the individual. Everything—design, color, rhythm—is controlled by the intelligence of the artist. The painting is "designed" just as the dagger-blade is designed—in view of the aesthetic value of the inherent formal elements. *Photo: Marc Vaux*

right
5 : Ceremonial dagger-blade of jade. Chinese; Chou dynasty (1122–255 B.C.). Based on functional prototypes the "shapes" of which have been transferred to a useless but precious material. There can be little doubt that the makers of these objects perceived the extraordinary aesthetic appeal of these functional forms, and for that reason made them with that care and sensibility which give them an abstract and universal appeal. The sensuous appeal of the material disappears to some extent in a reproduction, but one may still observe the subtlety of the curved point of the blade, and the sure placing of the pierced hole (for mounting the handle) in relation to the general shape of the object. *Private Collection*

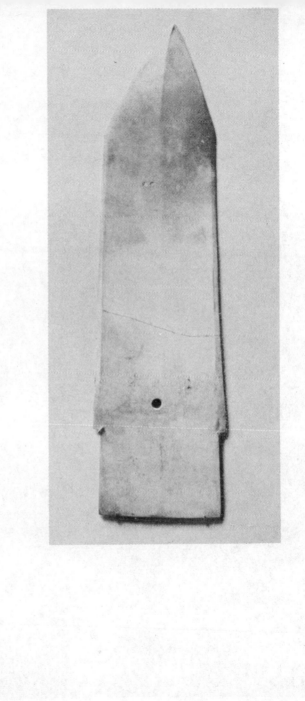

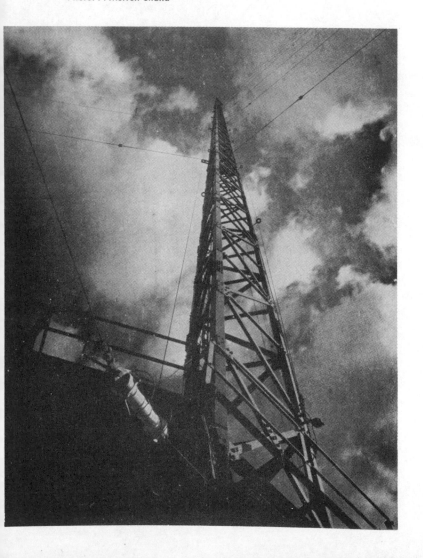

► These two photographs illustrate architectural forms which, though evolved strictly in response to functional requirements, yet possess definite aesthetic appeal. The lack of an aesthetic intention in the minds of the designers (assuming such to have been entirely absent) does not invalidate either the aesthetic fact or the aesthetic experience. Gothic verticality may have evolved in exactly the same way—the engineering solution of a problem preceding the consciousness of a resulting aesthetic experience.

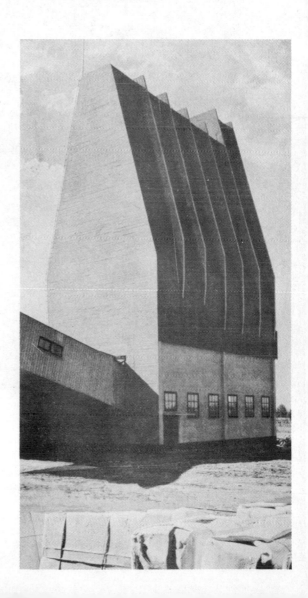

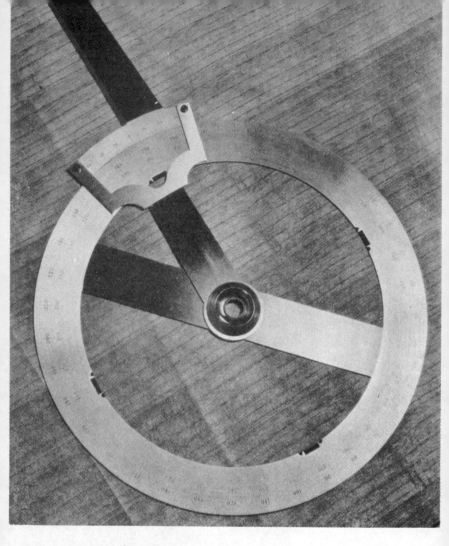

8 : Protractor. Eugene Dietzgen Co. Inc.
Photo: Museum of Modern Art, New York

► *Illustrates beauty inherent in simple machines of mathematical precision. Precision implies economy of material and utmost clarity—two essentials of a work of art.*

right top

9 : Earthenware drinking cup. Attic; about 530 B.C. Photo: British Museum

right bottom

10 : Earthenware vase. Chinese; Sung dynasty (A.D. 960–1279). Photo: Messrs. Bluett

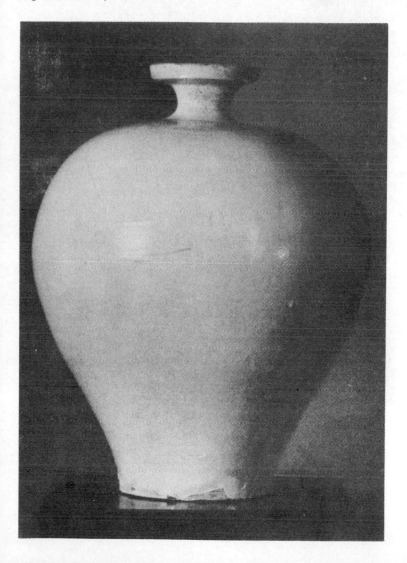

► *The contrast between this cup and the vase below is discussed in the text. The Attic vase belongs to a type susceptible to geometric analysis, consistent with regular canons of proportion (rational form); the Chinese vase can be submitted to a similar analysis, but in outline and finish it is slightly irregular (intuitional form).*

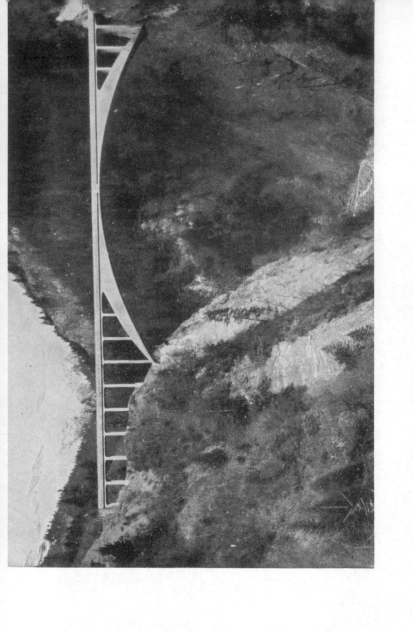

11 : The Salginatobel Bridge in the Engadine, constructed 1929–30 (span: 90 meters). Robert Maillart, engineer. *Photo: P. Morton Shand*

12 : Studebaker, 1953, designed by Raymond Loewy. *Photo: Alexandre Georges.*

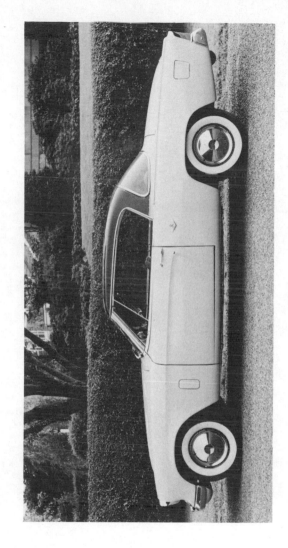

▶ *These two illustrations are confronted to show how nearly, once the element of scale is abolished, the engineer's and architect's designs approach each other in aesthetic effect. Entirely different problems are being solved; but the same absolute sense of order and harmony presides over each functional fulfillment.*

13 : Offices and printing works of the *Turu Sanomat* newspaper, Abo, Finland. Architect Alvar Aalto. *Photo: P. Morton Shand*

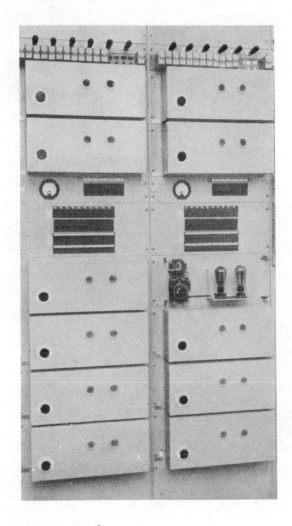

14 : "C" amplifier bays (with cover removed from one of the amplifiers). Broadcasting House, London. *Photo: B.B.C. copyright*

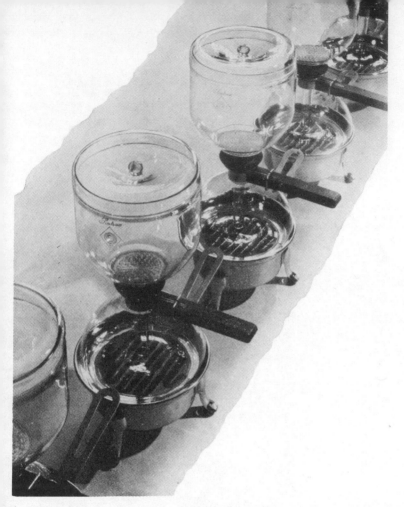

15 : Sintrax coffee machines in fireproof glass. Made by the Jena Glassworks.

16 : Airtight jars for tea or coffee. Made by the State Porcelain Works, Berlin.

▶ *Objects standardized for mass production. Each object, a good design in itself, has nothing to lose in aesthetic value when assembled as a series of standardized units.*

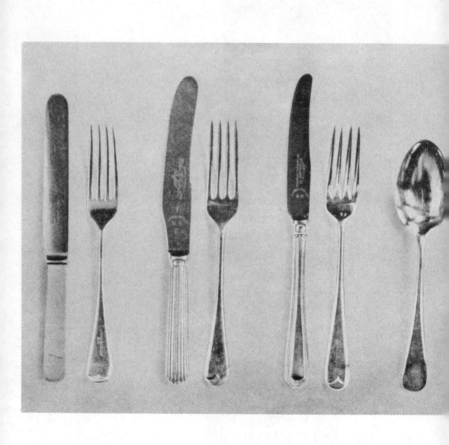

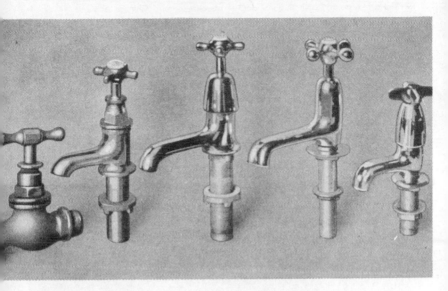

left

17 : Evolution of cutlery in use at Messrs. Lyons's restaurants (left to right).
Photo: "Design for Today"

► *These objects represent a return to the better forms of previous ages (see Figure
48) but no deliberate imitation is involved. Utilitarian considerations have perhaps
helped to modify the shape of the knife (to give a better cutting angle, reduce the
blade, which needs most upkeep, to a minimum) but probably the main factor has
been a sense of aesthetic form.*

above

18 : Evolution of the modern tap, left to right: No. 1. Brass tap of fifty years
ago. No. 2. Brass tap of thirty-five years ago, body improved and decreased
in size. No. 3. First example of an Easyclean tap with escutcheons covering
"the works"; about 1910. No. 4. Modern standard streamlined chromium-
plated tap. No. 5. Latest tap with piston valve and escutcheon rising with the
capstan head so that no spindle shows. Chromium-plated brass. All made by
G. Jennings and Co. Photo: "Design for Today"

► *This is an excellent example of design applied to an object that would not nor-
mally be regarded as worthy of aesthetic consideration. Nor is the evolution wholly
determined by functional considerations; a sense of form quite independent of
function is obviously embodied in the final designs.*

19 : The art of pottery at its highest degree of refinement: a Chinese porce-
lain vase of the Sung dynasty (A.D. 960–1279). Some influence of organic
forms—of the bell-shaped flower and the ribbed gourd—may have modified
the "natural" form that clay assumes on the wheel, but such forms are not
inconsistent with the technique, and in this particular case may be held to
emphasize the general shape, as they certainly increase its rhythmic complex-
ity and refinement. The base is an interesting elaboration of the same device
seen in all its primitive simplicity in the next figure. Contrast, too, the "tex-
tures" of the two objects. *Photo: Victoria and Albert Museum*

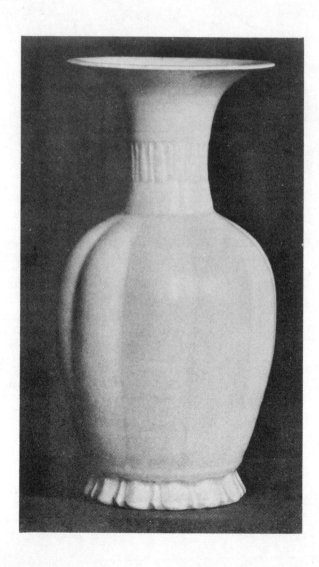

20 : This medieval English earthenware jug illustrates most of the natural qualities of pottery form. The baluster shape is one determined by the rhythmic expansion and contraction of the clay as It rIses from the revolving wheel between the potter's fingers. The base, thickened and splayed out with the potter's thumbs, pressing at the edge to give a firm outer contact, gives the jug stability. The handle springs from the body in a curve sympathetic to the general outline of the pot, and is placed in the most convenient position for pouring. The few scored lines of decoration emphasize the form, and are strictly related to the technique of manufacture.

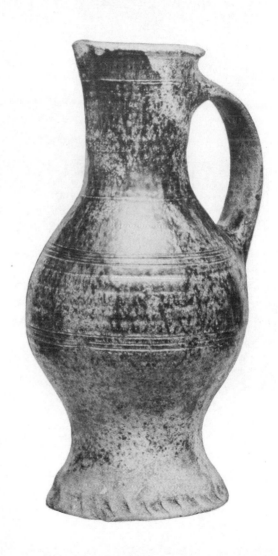

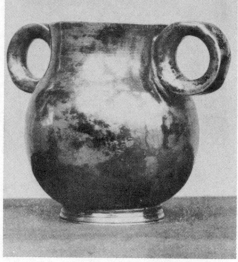

top

21 : Jar of "Chun" ware, Chinese, Sung dynasty. Photo: Messrs. Bluett

bottom

22 : Silver mug. English, dating from late seventeenth century. Photo: Victoria and Albert Museum

▶ *These two objects illustrate the basic globular form common to all plastic materials when designed to hold a substance to which direct access is desirable by lips, fingers, or a utensil—as distinct from substances which can be poured through a spout.*

23 : Coffee set of earthenware, designed by Otto Lindig at the Bauhaus, Germany.

► *These pottery jugs illustrate the pear-shaped form appropriate to a vessel made of plastic materials and designed to hold a liquid which can be poured from the spout. The form gives a low center of gravity and therefore stability; it pours without over-spilling. The cups illustrate the normal open cup form, ideal for drinking from.*

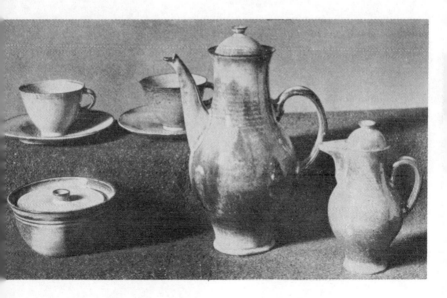

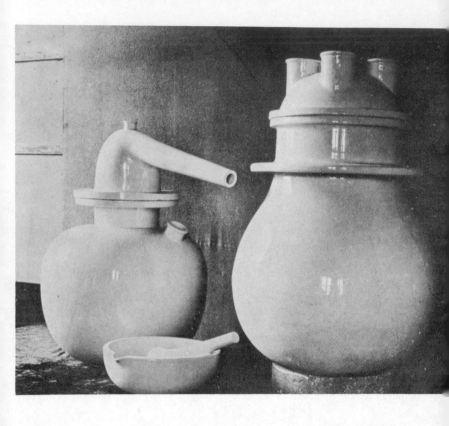

24 : Distilling vessels and a mortar. State Porcelain Works, Berlin. Vessels designed for tensile strength and fireproof qualities—functional purposes into which no thought of "decorative" values has entered. But note how closely in essentials the Wedgwood pottery below—intended to have an aesthetic appeal—approaches to this severely practical ware.

25 : Modern Wedgwood pottery. The "Queensware" cup and saucer and sugar basin, as well as the teapot in black "basalt" ware, are functional designs evolved in the latter part of the eighteenth century, which have persisted primarily because of their efficiency. But all the forms approximate to simple basic types, and their beauty is due to their precision and simplicity, and their geometric harmony. *Photo: Messrs. Wedgwood and Co.*

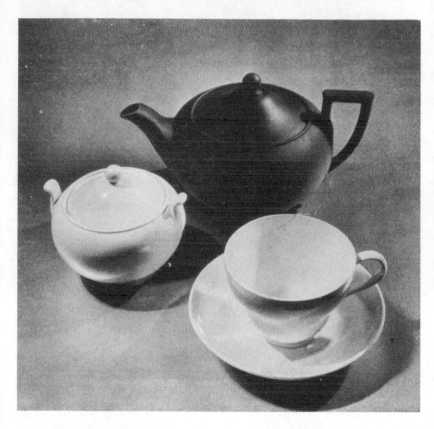

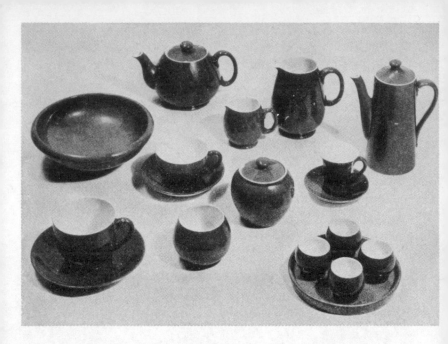

26 : Dark speckled-blue porcelain—a morning tea set designed by William Moorcroft and made by W. Moorcroft Ltd., Burslem. Modern pottery embodying the tradition of simplicity, precision, and the appeal of pure form.

27 : Pottery designed by Eva Zeisel. Produced by Castleton China, Inc. *Photo: Walter Civardi*

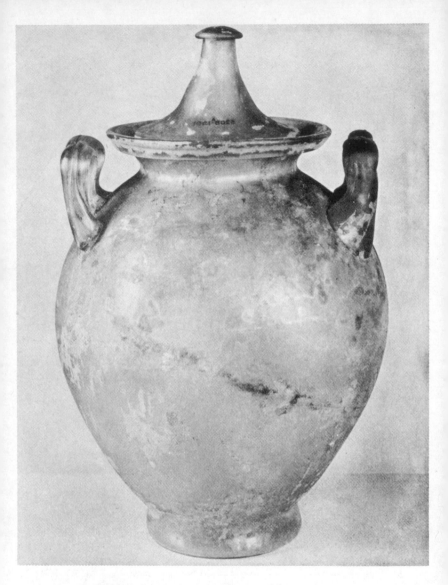

28 : Roman cinerary urn. A simple basic form, proclaiming the ductility of the material—the body a blown bubble, the handles viscous strands that still retain a suggestion of the molten condition in which they were formed. *Photo: Victoria and Albert Museum*

29 : The bubble reinforced by ductile strands of molten effect. A typical example of the art of the Venetian glassblower (of the seventeenth century)—"such fantastic and fickle grace as the mind of the workman can conceive and execute on the instant." Ruskin, when he used this phrase, probably had in mind some of the more elaborate types of Venetian glass, but this example combines grace and simplicity. *Photo: Victoria and Albert Museum*

below

30 : Glass of lead. An early example (about 1700) of this English invention. Much brighter and heavier than the Venetian "soda" glass, the form duly exhibits these qualities in its sturdiness and density, while still retaining the basic forms of a ductile material. *Photo: Victoria and Albert Museum*

right

31 : Wineglasses designed by A. D. Copier. Made by the Glasfabriek, Leerdam, Holland. *Photo: Instituut voor Sieren Nijverheidskunst, The Hague*

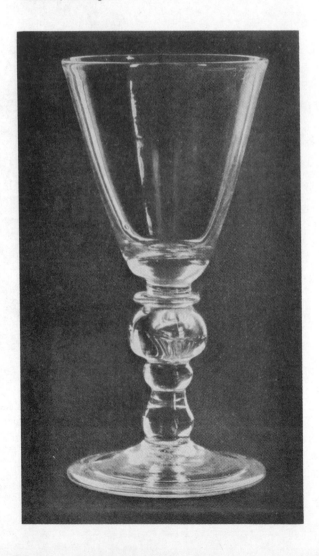

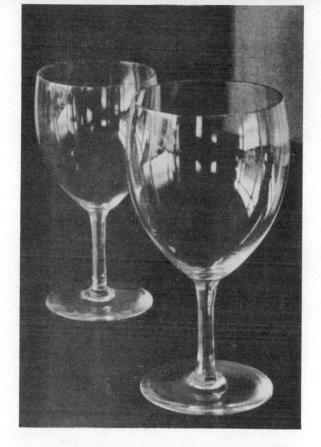

► *The baluster stem of the eighteenth-century glass is a period "mannerism," but compatible with efficiency, and a coherent part of the whole design of the glass. The modern Dutch glasses are devoid of mannerism, but their formal appeal is not thereby affected; the tulip-shaped bowls require a straight stem to complete the sense of an underlying organic form.*

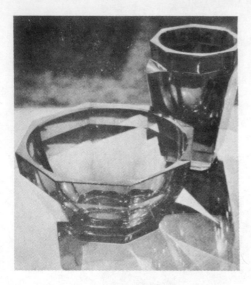

32 : Bowl and vase of cut glass, designed by A. D. Copier. Made by the Glasfabriek, Leerdam, Holland. *Photo: Instituut voor Sieren Nijverheidskunst, The Hague*

▶ *Modern industrial forms, exploiting the crystalline quality of thick glass. Glass no longer as a tensile material formed by the breath, but a plastic material, cast or molded.*

below

33 : Sherry set. Designed by Barnaby Powell. Whitefriars Glassworks, Wealdstone.

▶ *Tumblers of this type can be molded by automatic machinery. Stability is secured by a solid base.*

right

34 : Vases in "Ariel-technique." Designed by Sven Palmquist, Sweden.

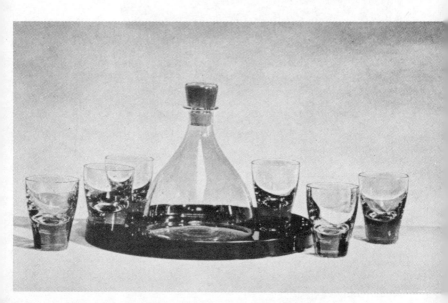

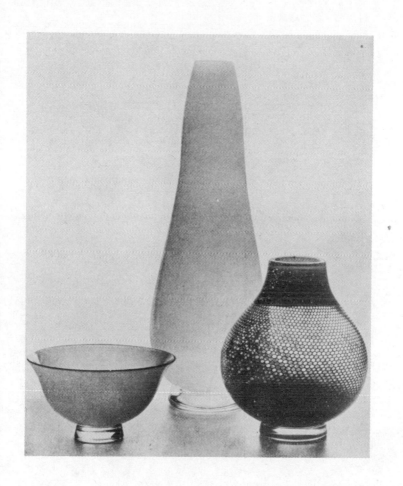

below

35: Teapot of Sheffield plate. English; about 1780. *Photo: Victoria and Albert Museum*

right top

36 : Coffee service, designed by Marianne Brandt at the Bauhaus, Germany.

▶ *These objects represent two stages of development in metalwork design—simple handicraft, designed to a definite capacity; first stage of standardization and rationalized production—cutting from sheet metal, elimination of irregularities; and contemporary design for machine production. At each stage a constant aesthetic appeal.*

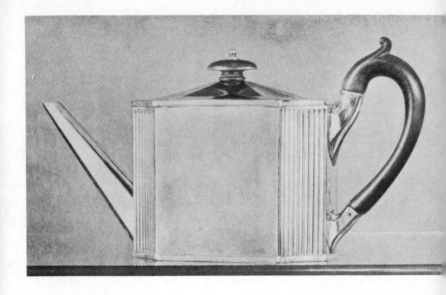

right bottom

37 : Crusader hotel saucepans. Lalance and Grosjean Mfg. Co. *Photo: Museum of Modern Art, New York*

▶ *Good proportions, perfect precision, beauty of "finish"—in what essential qualities do these ordinary examples of machine art differ from the Attic vase illustrated in Figure 9?*

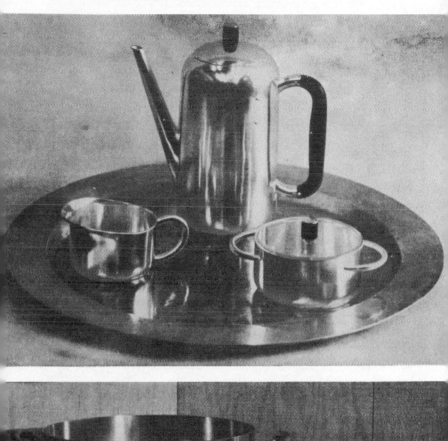

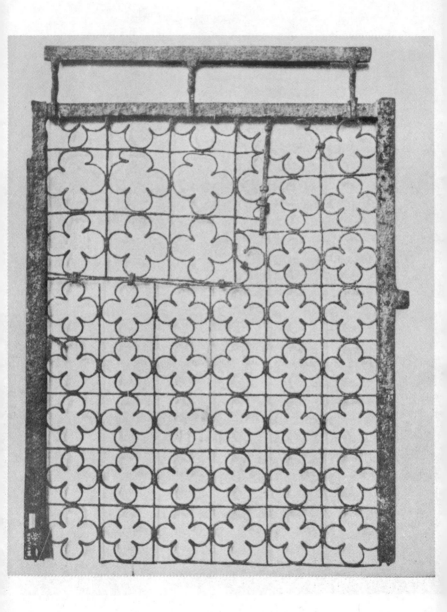

38 : Wrought-iron grill. English; thirteenth century. *Photo: Victoria and Albert Museum*

39 : Gas meter for Gas Light and Coke Company. Working prototype. Designers: Misha Black, O.B.E., F.S.I.A., M.Inst.R.A., and J. Napier Proctor. Registered Design No. 847809.

▶ *These two illustrations show extremes of development in the technique of working metal, both, however, based on the essential ductility of the material. The medieval grill is wrought by hand and uses a simple ornamental motif with great sensibility. The modern metal casing is designed by an architect and reproduced in standard molds by powerful machine presses. The former, cursive and organic; the latter, abstract and geometric; both aesthetic, appealing to the sense of form.*

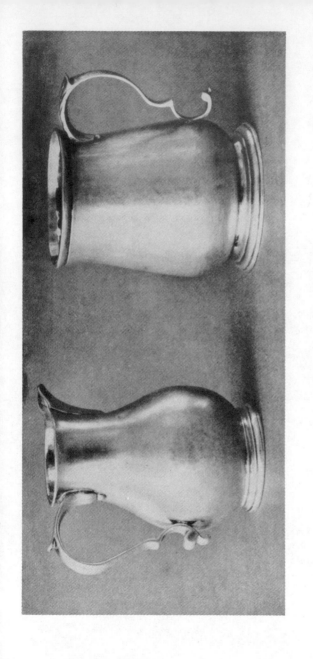

40 : Mug and cream jug of silver. English; eighteenth century. Photo: Victoria and Albert Museum

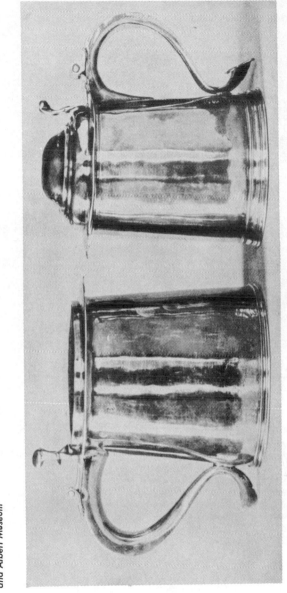

41 : Two tankards of silver. English; 1673–4 and 1702–3. Photo: Victoria and Albert Museum

▶ These two illustrations show the contrast between the rounded plastic forms beaten up out of the malleable material; and the straight cylindrical forms cut from the beaten sheet. Both are appropriate to the material, but the cylindrical forms are more obviously metallic.

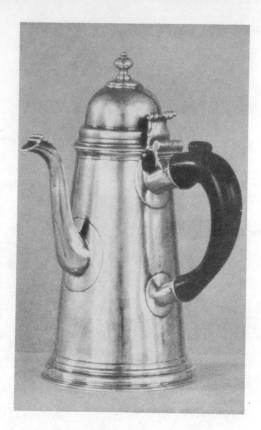

42 : Silver coffeepot, designed by Isaac Dighton. London; 1705–6. Photo: Victoria and Albert Museum

▶ *Adaptation of a basic geometric form (the cone) to a functional use. The problem of spout and handle has been solved by a bold exaggeration, typical of the mannerism of the Baroque period. Compare with the contemporary glass illustrated in Figure 30.*

right
43 : Three perforated metal bowls, designed by Gross and Esther Wood and manufactured by Gross Wood Co. Three metal bowls, designed by Harold Elberg. Cigarette box, oxidized metal and brass, designed by Paul Hagenaur.

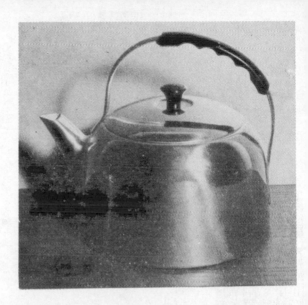

44 : Aluminum teakettle, designed by Lurelle V. A. Guild. Made
by the Aluminum Cooking Utensil Co., U.S.A. Photo: Museum of
Modern Art, New York

► *Functional considerations have determined various features of this
design—the broad spread of the base, to obtain the maximum heating
surface; the pitch of the handle, to facilitate pouring; the heat-proof
molded grip; the efficient spout. But these functional elements have
been embodied in a design which, like that of the eighteenth-century
coffeepot, satisfies the eye as well as the intelligence.*

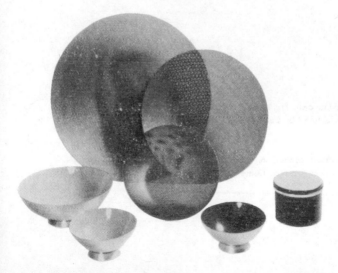

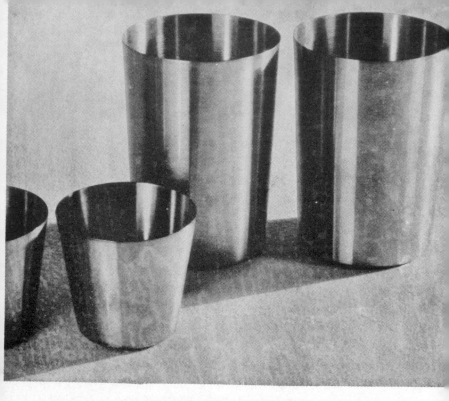

45 : Tumblers of rustless steel. Polar Ware Co., U.S.A. *Photo: Museum of Modern Art, New York*

right top
46 : Mexican baking dish. Frying pan, pyrex, with detachable handle. Designed and manufactured by Corning Glass Works. *Photo: Sumani*

right bottom
47 : Five-quart pressure cooker, sterilizer, and canner. Designed by Raymond Loewy Associates. Ekco Products Company, Chicago, Illinois

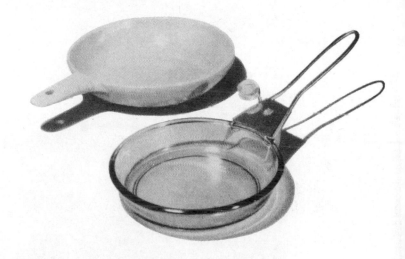

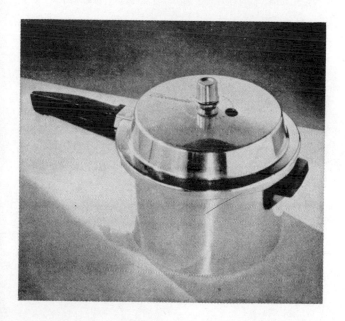

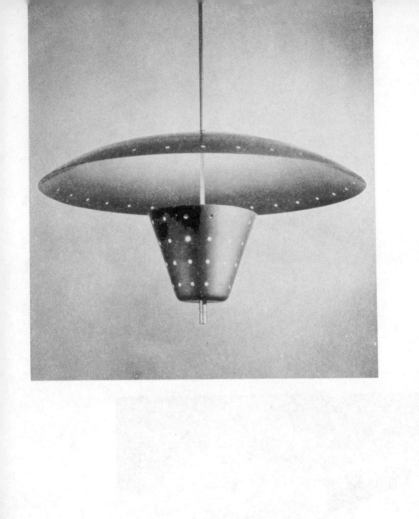

Pendant lighting fitting. Designed 1951 by Gaby Schreiber, F.S.I.A., and produced 1951 by Fredk. Thomas & Co. Ltd. Made in aluminum. Color-
ved and color-anodized finish.

Table lamp. Designed 1953 by Harry Gitlin. Produced by Ladlin Light-
Inc., New York. Lacquer on steel.

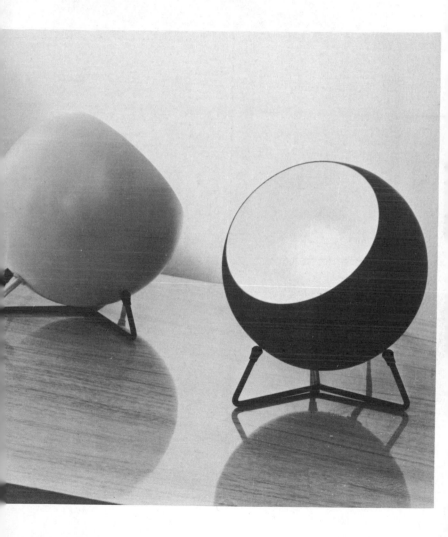

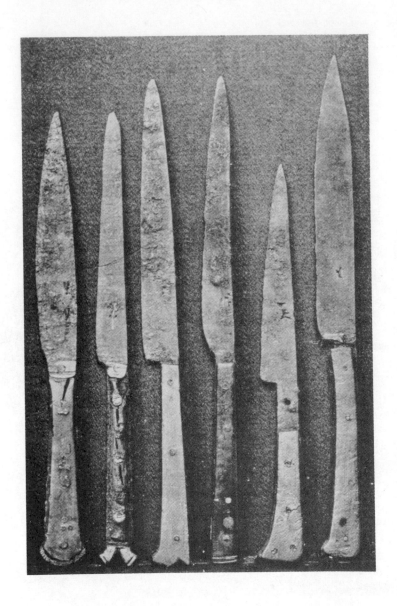

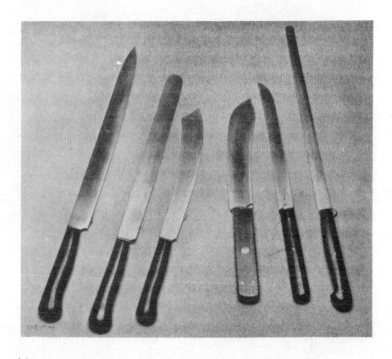

left
50 : Steel knives dug up in London. English: sixteenth century. *Photo: Victoria and Albert Museum*

above
51 : Steel knives made by Hermann Konejung, Solingen, Germany. *Photo: C. Rehbein, Berlin*

▶ *It is interesting to note the persistence, in the modern knife-forms, of the basic designs of the sixteenth century. It is unlikely that there is any conscious imitation; the forms, both of blade and handle, are in each case functional; and the function being constant, there is little scope for appropriate variation.*

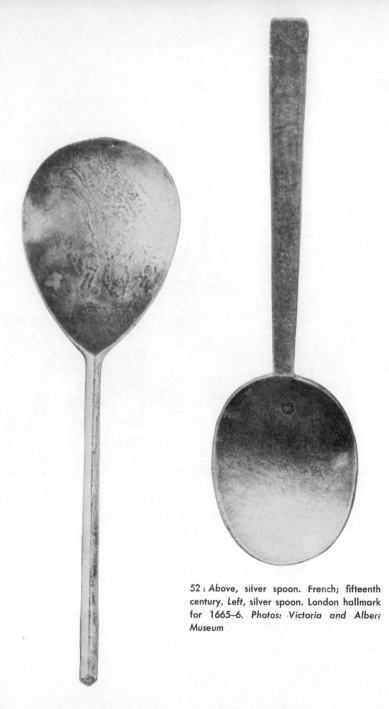

52 : Above, silver spoon. French; fifteenth century. *Left,* silver spoon. London hallmark for 1665–6. Photos: Victoria and Albert Museum

53 : Serving spoons. Württembergische Metallwarenfabrik, Germany.

▶ *Another interesting example of the unconscious return, under functional guidance, to simplicity of form.*

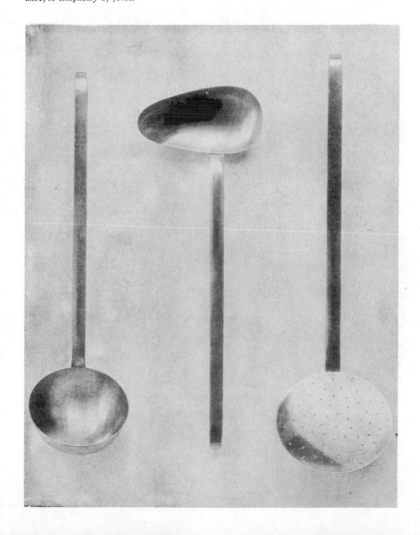

54 : Smokers' tongs. English (Sussex); eighteenth century. From the collection of the Lady Dorothy Nevill. Photo: Victoria and Albert Museum

55 : Tailor's scissors. Made by H. Boeker and Co., Solingen, Germany. *Photo: C. Rehbein, Berlin*

► *Instruments for gripping and cutting. In each case the particular function implies an action, which is expressed in the design and gives the object a definite vitality.*

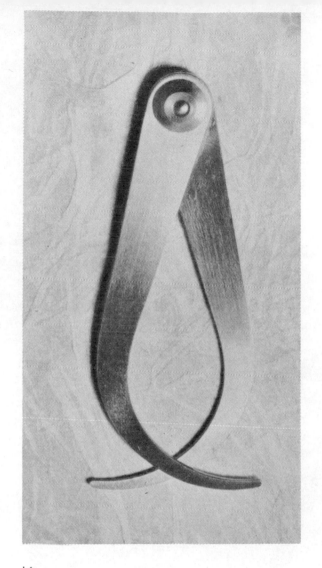

58 : Salad basket, metal wire. Designed by M. Schimmel. Manufactured by Raymar Industries, Inc. *Photo: Sumani*

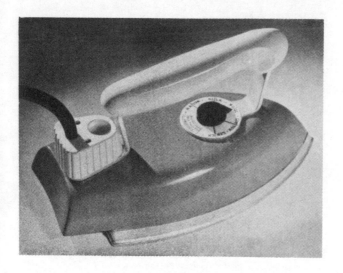

59 : Electric iron designed by Sadie Speight for Beethoven Electrical Equipment Ltd. Prototype only. Design Research Unit.

right

60 : Pewter measure. English; first half of sixteenth century. *Photo: Victoria and Albert Museum*

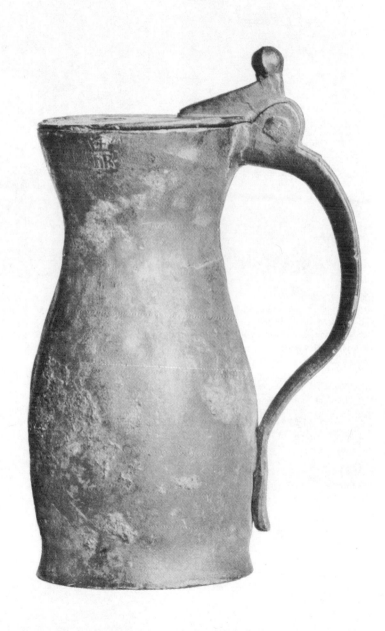

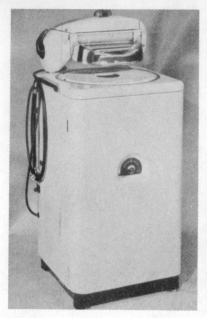

left

61 : "Parnall" electric washer. Designed and first produced 1950 by Parnall (Yate) Ltd. Made of sheet steel; pressed steel. Plastic agitator. Wringer feeder boards—aluminum-magnesium alloy. Finish white synthetic baked enamel. Control handles in red.

right

62 : "Policy" duplicator. Designed 1949 and first produced 1950 by Roneo Ltd. All-metal construction. Polychromatic finish.

right top

63 : Canteen wagon. Made by the Berndorfer Metallwarenfabrik (Arthur Krupp, A.G., Esslingen, Germany).

▶ *Steel tubing used in a most direct and practical way. The designs are severely structural, and do not at first sight suggest aesthetic qualities; but the same might be said of the external buttressing of a Gothic cathedral.*

right bottom

64 : "Thor" clothes and dish washing machine. Designed and first produced 1946 by Thor Appliances Ltd.

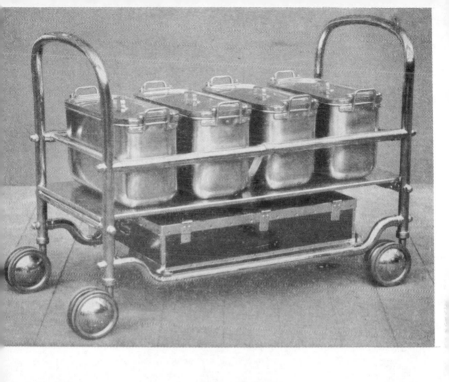

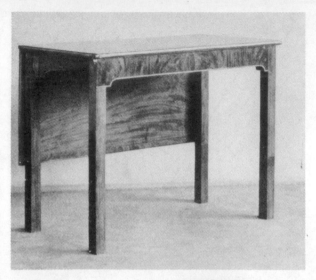

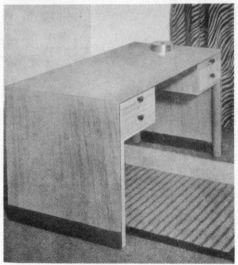

65 : Portable table of mahogany. English; about 1770. *Photo: Victoria and Albert Museum*

66 : Writing desk in oak, inlaid bog-oak; Made by Gordon Russell, Ltd. *Photo: W. Dennis Moss, Cirencester*

▶ *Both objects are comparable, not only in their combination of ingenuity and simplicity, but also in their controlled elegance, and in their exhibition of the inherent beauties of the material.*

right
67 : Dining-room furniture in Indian silver greywood, upholstered in blue wool tapestry. Made by B. Cohen and Sons, Ltd.

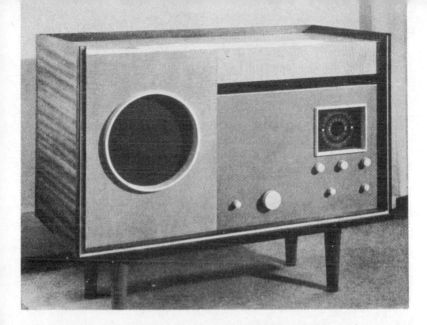

68 : Radio-gramophone. Designed 1949 by Trevor Dannatt, A.R.I.B.A., and first produced 1950 by Stoneman & Waterman. Mahogany case and base with sycamore veneers. Gray "Wareite" instrument panel and finger recess in ebony. Viridian green material to speaker front.

▶ *Examples of modern furniture designed in the straight "linear" tradition determined by the fundamental fibrous growth of the raw material. The radio cabinet is an outstanding example of the application of traditional forms of the best kind to a specifically modern need. A different solution of the same problem is illustrated in Figure 84. The dining-room suite is designed for mass production by a firm of wholesale and export cabinetmakers.*

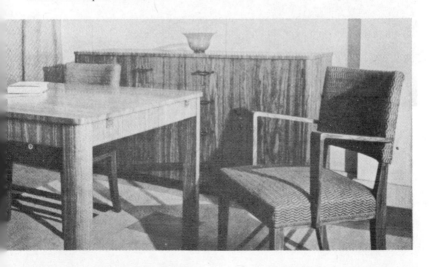

69 : Demonstration model of a prize-winning chair designed by E. Saarinen and Charles Eames. The shell is formed of laminated strips of veneer and glue pressed in a cast-iron mold, and upholstered in rubber and fabric. *Photo: Museum of Modern Art, New York*

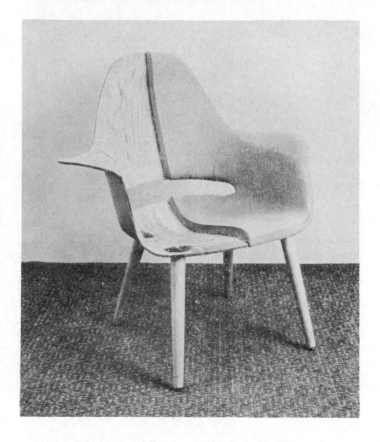

right
70 : Armchair of beech and ash. English; about 1800. *Photo: Victoria and Albert Museum*

71 : Upholstered armchair, designed by "Plan" Ltd. Sprung on patent steel band suspension, with the upholstery easily removable on the press-button principle. *Photo: Studio Sun Ltd.*

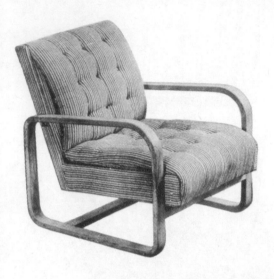

72 : "Plan" steel chair, designed by Serge Chermayeff. *Photo: Studio Sun, Ltd.*

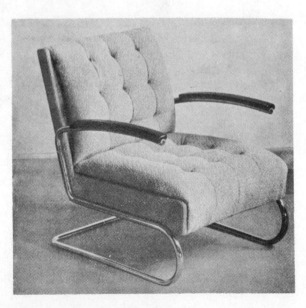

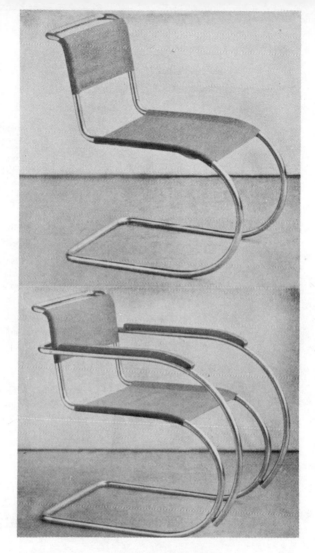

73 : Two steel chairs, designed by Mies van der Rohe. Made by Thonet Bros.

▶ *Mies van der Rohe's design for a tubular steel chair is a classical solution of the form demanded by the material in relation to the function—a structure taking full advantage of the possibilities of the material—its strength and elasticity—and entirely emancipated from the concepts of wooden furniture. Mr. Chermayeff's design (Fig. 72) is an application of the same principle to the easy chair. In both armchairs the applied ebonite strip to the arms obviates the only disadvantage of steel furniture—its coldness to the touch.*

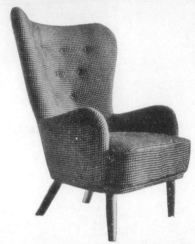

above

74 : Easy chair. Ernest Race Ltd. Frame of electrically welded mild steel rod. Legs of polished beech with steel bolt core. Fabric cover.

left

75 : Dining chair. Ernest Race Ltd. Legs and seat frame of die-cast aluminum alloy. Seat of molded foam rubber. Back of padded plywood.

below

76 : Preform easy chair. Designed by Robin Day, A.R.C.A., F.S.I.A. First produced 1951 by S. Hille & Co. Ltd. Steel rod, foam rubber, hand-woven material. Arms, sides, and back of chair are molded in one piece and supplied in various veneer finishes. Seat and back are preformed and upholstered in foam rubber.

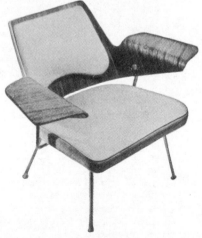

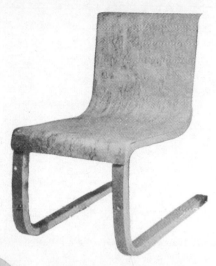

above & below

78 : Composite plywood furniture designed by Alvar Aalto. A patent process of laminating the plywood gives it unusual elasticity and carrying power. The simplified forms can be mass-produced in standardized units. The upper surface is enameled or veneered with woods of decorative grain.

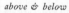

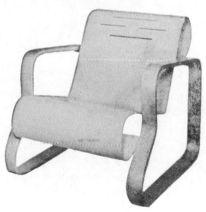

above

77 : Danish chair. Designed by Peter Hvidt and O. Molgard Nielsen. In current production 1950. Made by Fritz Hansens Eftfl, Denmark. Copyright "Bonytt"

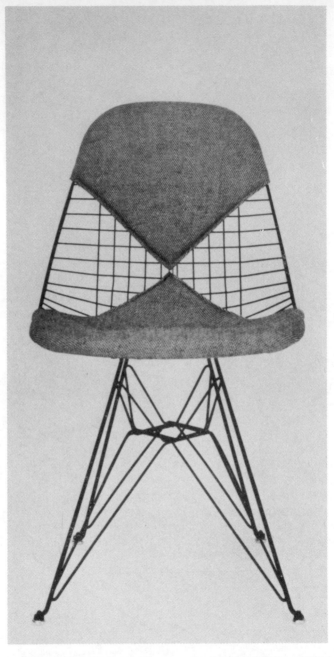

79 : Formed wire on high wire base, two piece fabric pad. Designed 1951 by Charles Eames. Manufactured by Herman Miller Furniture Co.

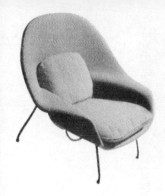

80 : Molded sheet plastic, upholstered; with loose cushions and metal rod support. Designed 1948 by Eero Saarinen. Manufactured by Knoll Associates.

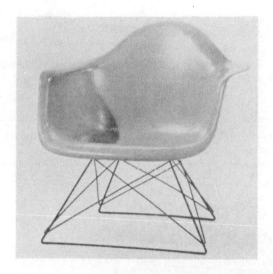

above

81 : Detachable metal base and molded plastic shell. Plastic reinforced with glass fibers. Designed 1948 by Charles Eames. Manufactured by Herman Miller Furniture Co. *Photo: G. Barrows*

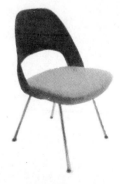

82 : Foam rubber upholstery, metal rod legs. Designed 1949 by Eero Saarinen. Manufactured by Knoll Associates.

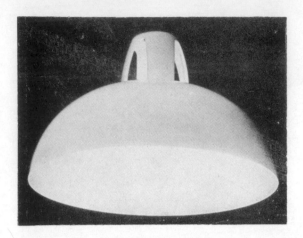

83 : Electric lighting fitting. Designed and first produced in 1945 by Benjamin Electric Ltd. Made of urea-formaldehyde plastic moldings.

84 : Radio cabinet (Ekco model 74) designed in bakelite by Serge Chermayeff.

► *The radio cabinet is an example of the encroachment of new plastics materials, such as bakelite, on a province hitherto reserved for wood. Such new materials are suitable for any plastic design, especially where lightness and a surface pleasant to touch are in question.*

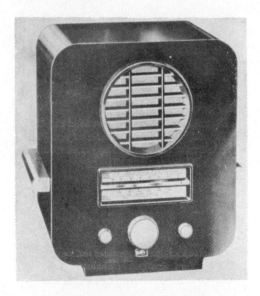

85 : Three-piece mixing bowl set of flexible polyethylene plastic. Special "hand fitting" handle, unbreakable plastic lip for easy pouring, hole for hanging; or bowls can be nested for storage. Manufactured by the Plas-Tex Corp. *Photo: Merchandise Mart News Bureau*

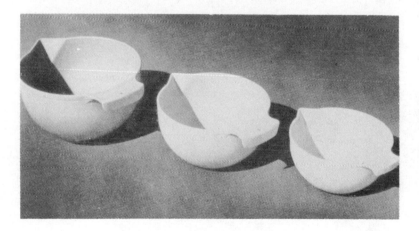

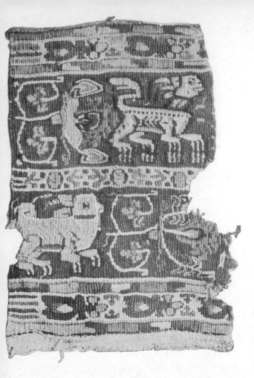

86 : Portion of a sleeve panel; tapestry woven in colored wools and linen thread on woolen warps. Coptic; sixth–seventh century.

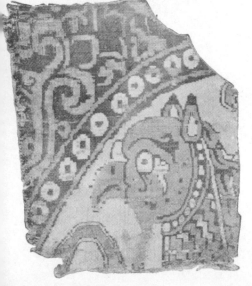

87 : Silk tissue. Byzantine; tenth–eleventh century. *Photos: Victoria and Albert Museum*

▶ *The structural basis of these designs is openly revealed in the geometrical nature of the patterns. Fabric structure is essentially numerical—arithmetical combinations and permutations of a given number of weft threads within a fixed and invariable warp. Good textile design is not afraid to reveal its geometrical foundations.*

88 : Form is already inherent in the fleece and yarn: thin and wiry, soft and delicate, smooth, firm, or coarse—these are qualities in the raw material which determine the texture and pattern of the cloth to be woven. *Photo: Ronald Thompson, B.Sc.*

89 : The living texture of cloths which respect the nature of the raw materials. Woven by children at Howell's School, Denbigh.

90 : Fabric of cotton and wool, woven on machine looms into a pattern which makes full use of the contrasted textures of the two materials. Made by the Edinburgh Weavers.

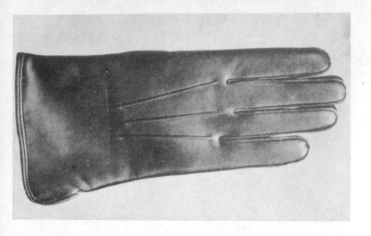

91 : Men's gloves in cape leather, fleece lined. Designed 1949 and made by the Yeovil Glove Co. Ltd.

92 : Air-travel handbag and round case. Designed 1950 and produced by Fibrenyle Ltd. Fibrenyle foundation covered with Fibrenyle impregnated raffia weave.

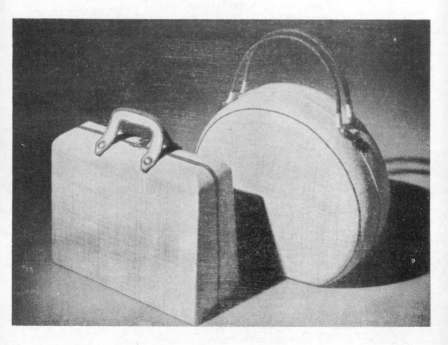

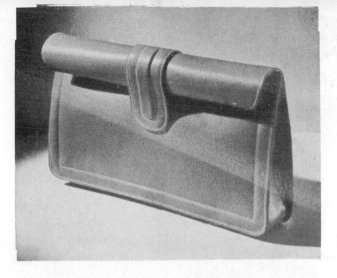

93 : Handbag in chromed tanned calf. Designed 1948 by F. M. Jennings, M.S.I.A. First produced 1948 by J. Jones & Sons (Birmingham) Ltd.

94 : Red leather handbag made by Sternschein & Seidler Ltd., Glasgow.

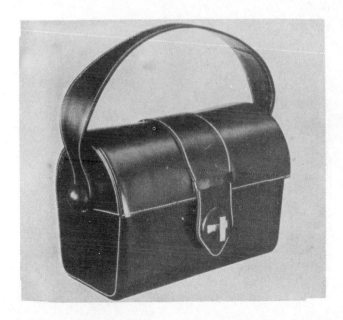

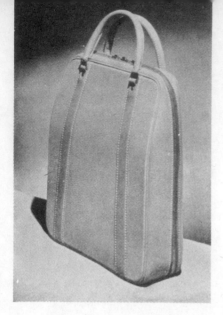

95 : Carrying case for typewriter. Designed by John N. Waterer, F.S.I.A. First produced 1951 by S. Clarke & Co. Ltd.

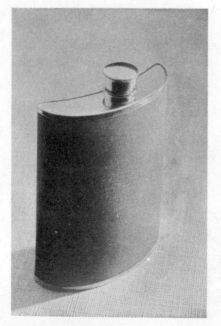

96 : "Eldonian" eight-ounce flask, covered with pigskin. Designed and made by George Sheldon (Walsall) Ltd. Curved to fit pocket. Polished tin coating on copper not subject to corrosion.

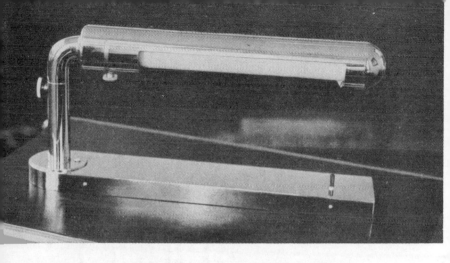

97 : Electric lamp, designed by N. Slutzky, at the Bauhaus, Germany.

▶ *The similarity of these two "constructions" is admittedly fortuitous. The lamp is designed for function and appeal; the switch primarily for function, but incidentally it has its appeal—an appeal of lines and masses harmoniously organized.*

98 : An "A" relay switch, from Broadcasting House. *Photo: B.B.C. copyright*

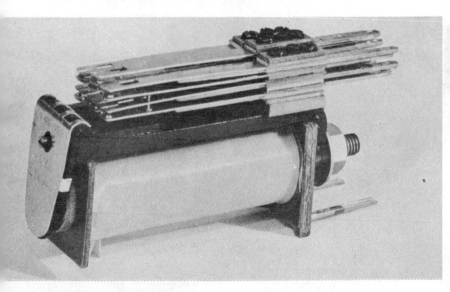

99 : Electric hanging lamp. Designed and made by Best and Lloyd, Ltd. *Photo: Arthur Gill*

100 : Electric radiator. Designed for the Cresta Silks Factory, Welwyn Garden City, by Wells Coates.

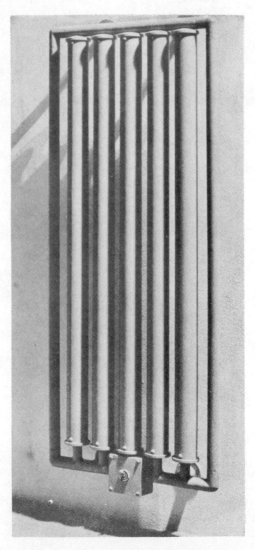

101 : Aga Model C.B. cooker and water heater. The fire assembly is made in a special heat-resisting chromium alloy; outer finish in chrome and vitreous enamel. Designed by Dr. Gustaf Dalén. Made by Aga Heat Ltd.

► *This cooker, and the Wells Coates radiator, are excellent examples of architectural principles of design applied to objects of daily use. Dr. Dalén, the designer of the Aga cooker, is a physicist of world-wide fame, a winner of the Nobel Prize; his aim was in the first place to produce a cooker which combined the highest efficiency with very low running costs; but what should be noted here is the way in which these requisites have been ordered into a design of admirable proportions. A pleasant detail, for example, is the way in which the oven-door hinges, designed for a practical purpose, are given a very definite horizontal emphasis which contributes to the general harmony of the structure.*

102 : The executive's desk. Designed by Frederick Gibberd, F.R.I.B.A., for Roneo Ltd. This is designed as a series of interchangeable steel units so that different types of desks can be built up for special purposes.

right top
103 : Bell Telephone Laboratories, PBX switchboard. Designed by Henry Dreyfuss. Aluminum housing slips off without disturbing fixed wiring connections.

right bottom
104 : The "Scribe" portable typewriter. Technical design by Giuseppe Baccio and Ottavio Luzzati; styling by Marcello Nizzoli. First produced 1951 by Olivetti.

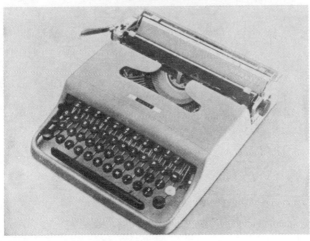

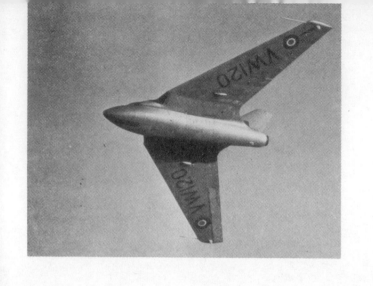

105 : The DH108 experimental jet aircraft, one-time holder of the world's speed record of 605.23 mph for 100 kilometers in a closed circuit, and the first British plane to fly faster than sound. 1946. Designed by Sir Geoffrey de Havilland, R.D.I.

below

106 : Vernier depth gauge; graduated-rod depth gauge for measuring the depth of holes; and diemakers' square for checking included angle of clearance in making dies. Made by Brown and Sharpe, of New York, Inc.

▶ *Another fortuitous comparison, of very diverse structural objects; but the similarity of formal appeal proves the absolute nature of the inherent aesthetic values, values totally independent of any functional explanation.*

107 : Temporary portable bus stop.
London Transport

108 : Lighting lantern. Tubular steel,
Holland

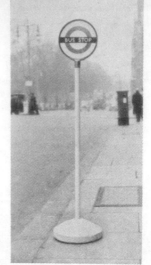

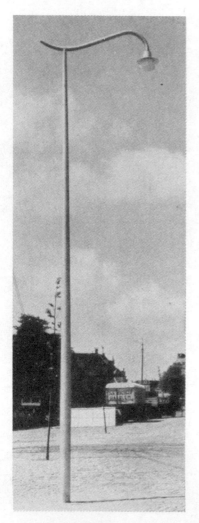

right top
109 : Aluminum-framed poster display
fixture. London Transport

right bottom
110 : Bus-stop post and frameless sign.
London Transport

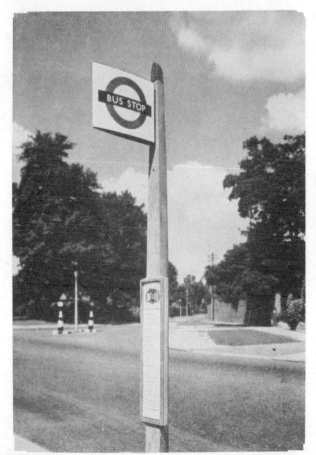

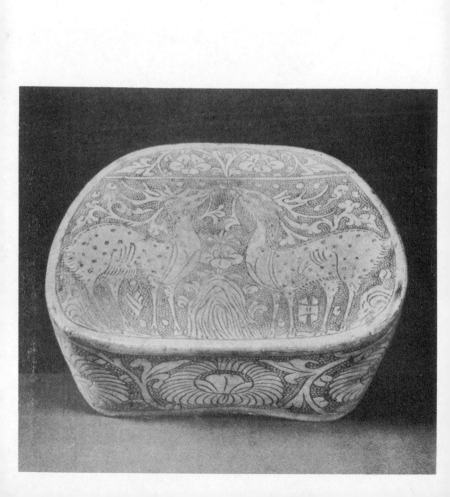

left

111 : Pillow of porcelain. Chinese; Sung dynasty.
Photo: Victoria and Albert Museum

▶ *The shape of this object though functional is in itself
uninteresting; it is given interest and vitality by the appli-
cation of a painted design appropriate to the form and
material of the object.*

above

112 : Bronze "celt" (adz or ax). Bronze Age. The celt
was cast in a mold, and the raised lines and circles are
a primitive form of ornament. It is possible to argue
that they were suggested by the thongs used to fasten
the celt to a haft, but their real origin is more likely
psychological, to relieve the blank surface of the ob-
ject, and to give it a vitality, almost animal-like in its
intensity. *Photo: Victoria and Albert Museum*

113 : Stoneware jar. Chinese (Canton); seventeenth century. Found in British North Borneo, containing two human skulls. *Photo: Victoria and Albert Museum*

▶ *A perfect example of structural ornament, both factitious (the graining of the lower unglazed part of the jar, due to the impress of a coarse cloth on the wet clay) and fortuitous (the varied transmutation of the glaze under the fire of the kiln).*

right

114 : Bronze cup (kio). Chinese; Chou style (1122–255 B.C.). This cup is a ritualistic object, divorced from its original function—it has become a mere vehicle for religious practices and as such its form develops into a pure plastic conception. The conventionalized ornament is subordinated to the form. It illustrates (a) positively, the tendency of form to become fantastic if not controlled by function; and (b) negatively, the insignificance of ornament when form is the primary concern. *Photo: Victoria and Albert Museum*

115 : Stoneware jar. Chinese; Sung dynasty. An example of "geometric" ornament, developed during the technical process. The ledges are cut into the pot when the clay has reached a certain degree of cohesion through drying, but before firing; the vertical lines were probably scored at the same time. The application of a glaze to the upper part of the pot produces a subtle contrast of soft and severe lines. *Photo: Victoria and Albert Museum*

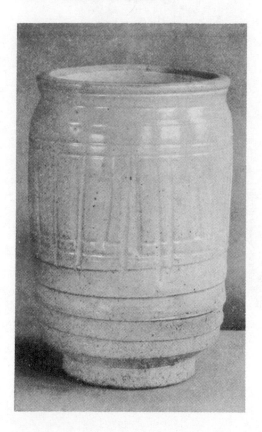

116 : Earthenware bowl. Persian; thirteenth century.
An example of "stylized" ornament, based on a plant
motif, which is distorted from its naturalistic form to
make a symmetrical design, sympathetic, in its move-
ment and rhythm, to the shape of the bowl. *Photo:
Victoria and Albert Museum*

117 : Porcelain bowl. Chinese (reign of Wan-li);
1573–1619. An example of "naturalistic" ornament,
pictorial in intention; but well adapted to the object.
The delicacy of porcelain as a material demands a
fine sensitive style of drawing; the shape of the bowl
a subject which fits into a circular frame. *Photo:
Victoria and Albert Museum*

118 : Porcelain jar. Chinese; Sung dynasty. Photo: Victoria and Albert Museum

▶ *The vertical ridges that decorate this pot run counter to the direction of the wheel; but their sharp downward fall admirably emphasizes the plastic form of the vessel.*

119 : Loincloth of cotton, with a pattern produced by the batik process, which consists of hand-painting and dyeing combined with a wax resist and mordants. Javanese; nineteenth century. The general effect is that of an "all over" pattern, but within the pattern there is infinite variation. *Photo: Victoria and Albert Museum*

120 : Textile block-printed in three colors. Designed by Paul Nash for Allan Walton Textiles, Ltd. *Photo: "The Cabinet Maker Magazine"*

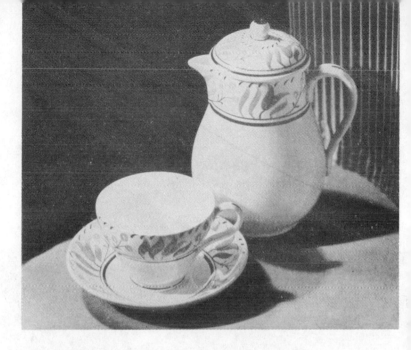

121 : Coffeepot and cup and saucer. Made by Messrs. Wedgwood.

122 : Earthenware cup. Chinese: Sung dynasty.

► *Two examples, ancient and modern, of ornament placed so as to emphasize the form of the object. The Chinese example succeeds better, because the ornament is easy and unconstrained; in the modern example, it seems timidly confined within its borders.*

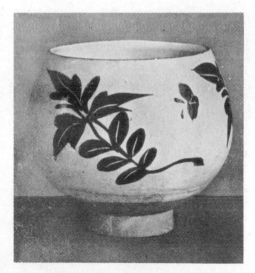

123 : Cigar album. Designed 1953 by Paul Rand for El Producto cigars.

124 : Ciné film cartons designed for Ilford Ltd. by Milner Gray, R.D.I., F.S.I.A., of Design Research Unit Ltd.

125 : Protective pack for coffee. Designed 1950 by Mather & Crowther Ltd., and produced by E. S. & A. Robinson Ltd. The printed paper is laminated to rubber hydrochloride film ("Drio-film") which makes a moisture-proof lining to the bag; printed in three colors.

left top
126 : Beer-bottle labels designed for Courage & Co. Ltd., by Milner Gray, R.D.I., F.S.I.A., of Design Research Unit, London.

left bottom
127 : Metal containers. First produced 1949 by The Metal Box Co.

above top
128 : "Imperial Leather" packs for shaving soap and solid brilliantine. Universal Metal Products Ltd. Plastic containers molded in two colors with screw lids. Copyright: British Industrial Plastics Ltd.

above bottom
129 : "Atkinson's" Talcum Powder Flexi Puff. Bottle-molded polythene with tag label printed on cellulose acetate sheeting. PAC Cosmetics and Toilet

130 : Packaging for "Bigren" oil designed by Sir William Crawford and Partners Ltd. Transparent plastic. Aladdin Industries Ltd.

APPENDICES

appendix A*

THE GORELL REPORT

On July 13, 1931, the British Board of Trade appointed a Committee under the chairmanship of Lord Gorell with the following terms of reference:

"To investigate and advise with regard to:

(a) the desirability of forming in London a standing exhibition of articles of every-day use and good design

* The material in this and the following appendices refers to conditions and institutions in Great Britain, but it is retained in this edition because the problems dealt with are essentially the same in the United States, and some of the solutions proposed for the one country may be applicable in the other.

of current manufacture, and of forming temporary exhibitions of the same kind;

(b) the desirability of organising local or travelling exhibitions of the same kind both at home and abroad;

(c) the constitution of the central body which should be charged with the work of co-ordinating the above activities;

(d) the amount of expenditure involved and the sources from which it should be provided."

The Committee, which was predominantly official in its membership, presented a Report on March 16, 1932. It will be observed that in comparison with some of the inquiries that have been set up to consider the relations of art and industry, the terms of reference are very limited in their scope, and presume one and only one mode of procedure—the holding of standing and temporary exhibitions. But the Committee, in the course of their investigation, found it necessary to review the general problems involved, and their Report is the first official recognition of the real nature of those problems. It begins with an historical survey of the subject, and of the methods hitherto adopted to deal with the situation created by the rise of machine production. I would draw particular attention to the following paragraphs:

"15. The movement that we have been tracing in bare outline has unquestionably exercised a profound influence on the course of development of the Arts in this country. It is equally undeniable that this influence has not been wholly beneficial, and also that the original stimulus thus given to Industrial Art has, in some large degree, exhausted itself, and needs to be reinforced by other measures. . . . The key to much that has happened may

perhaps be found in the original title of the National Collection as a Museum of 'Ornamental Art,' which, together with the popular use of the unhappy term 'applied art,' gave colour to the pernicious notion that Art is something superficial and extraneous to be 'applied' to an industrial product, instead of being an essential and organic element in the article itself. A general encouragement to the manufacturers to produce artistic wares, without any fundamental understanding of what Art really means and how it is related to material, quality of workmanship, and fitness of function, could only lead to the riot of pretentious and excessive decoration which characterised so much of the 'industrial art' of the middle of the 19th century, and which was bound to provoke a reaction."

Then, after referring to the Arts and Crafts movement associated with the name of William Morris, the Report proceeds:

"17. During the generation which followed the formation of the Arts and Crafts Exhibition Society in 1887, the influence of Morris and of the group of artist-craftsmen whom he inspired can hardly be over-estimated, though their effect on industrial manufactures was, generally speaking, less marked and more indirect than on the unique work of handicraft. Gradually this movement has, in its turn, lost some of its original force, not that its fundamental principles have ceased to be valid, but because they are not adequate to meet the conditions of large-scale production required to supply the needs of a modern community, and especially of consumers of moderate means. There has been a growing realisation of two facts: first, that a reversion to handicraft cannot, for economic reasons, solve the problem of beautifying the articles of

common use within the purchasing power of such con-
sumers; secondly, that the fundamental differences between
the technique of industrial manufacture and of handicraft
make the problem of adapting design to industry a wholly
different one from the production of unique specimens of
artistic workmanship. . . ."

The report of a committee is apt to be a composite docu-
ment, and one cannot demand too much consistency. These
two paragraphs show such a clear realization of the nature
of the problem (though the words "the problem of adapting
design to industry" at the end of the second paragraph are
a little ominous) that it is very disappointing, farther on
in the Report (§ 31), to find a sentence or two which seem
to slip back into the old errors. For example:

"It has been stated in public that manufacturers are
uncertain—mainly for want of proper *artistic advice*—what
style and design to follow in their new products; whether
to indulge in imitations of the past or in an ill-considered
form of so-called modern work. Yet here, in our own
country, are the potential advisers; we must now secure
scientific planning for the future and a continuous ex-
hibition policy administered with care and vision, designed
to make first-rate material readily accessible to all inter-
ested. If we adopt such a policy, coupled with first-rate art
teaching, first-rate opportunities for designers, and a new
determination on the part of manufacturers *to seek the
advice of the best artists* of the day, the remediable evils
of the present position will be gradually overcome, and the
country's Industrial Art will be based upon a secure foun-
dation. A constant market will then be available, both at
home and abroad: in highly protected countries purchasers
will always be found, even at higher prices, for goods
marked out from the ordinary by possessing really sound

and distinguished artistic quality. Such goods can only be produced *in collaboration with first-rate artists* at every stage of production."

I find it impossible to believe that this paragraph was written by the author of the previously quoted paragraphs, for it embodies precisely that error against which those earlier paragraphs so nobly protested: the conception of art as something external to industry, something formulated apart from the industrial process, something which the manufacturer can "take advice on," and import into his industry should he think fit—that is to say, if he thinks the "goods" will fetch a higher price if they have the artist's certificate attached to them.

After such disparity in the body of the Report, one cannot expect much force in the recommendations. In so far as these concern the policy of exhibitions, no objection can be taken to them; but exhibitions can serve no useful purpose unless there are things worth exhibiting, and this the Committee realized. Therefore, going beyond their terms of reference, they call for "concurrent measures," some of which must have been drafted by the hand that we detected in paragraph 31. "Steps should be taken . . . to secure that numbers of the leading and most promising artists and craftsmen of the day should be encouraged to turn their energies into the industrial manufacturing field . . ."; "means should be devised by which manufacturers should be able to obtain sound advice from some trustworthy source as to the artistic quality of their existing output, and as to the alternative quarters (!) from which improvement could be obtained. Manufacturers should find it more and more profitable to employ the very best artists and craftsmen, and to pay them generous fees in order to secure their best work. The best living Art of

each period would thus be used, as in the past, to beautify the nation's industrial products of all kinds." It would be difficult to match the ineptitude of this last sentence in the darkest confusion of the Victorian period; it expresses the central fallacy against which this book has been written. But one further recommendation is almost equally inept: "The Government and Local Education Authorities should vigorously promote the improvement of the art education of the country. They should consider ways and means for securing the services of first rate practising artists and craftsmen, in part-time capacity, for assisting in the work of training both the students in our art schools and all those connected with the producing and distributing of the industrial arts. Demonstrations in museums would probably be effective." In other words, the present half-hearted and abortive system should be continued unaltered; or rather, its pernicious effects should be "vigorously promoted."

It is not surprising that one member of the Committee, whose appreciation of the true nature of art cannot be doubted, should have found it necessary to add a Memorandum to the Report, giving his own views in more detail. With Roger Fry's "Analysis of the Existing Situation" I am in general agreement, though there are incidental statements (such as that "good architecture must always remain distinct from good engineering") which might be disputed. But the second part of his Memorandum, a "Scheme for Workshops of Decorative Design in British Industry," seems to imply that only the "decorative" arts are involved in a necessary reform—wallpapers, textiles, and interior decoration generally. It is impossible to suspect Roger Fry of having confused form and decoration; or even of having regarded decoration as the major problem; but one may regret that he did not take this opportunity to raise the

fundamental issues. He seems to have been more concerned to rebut the idea that when an object fulfills its function perfectly, it is, *ipso facto*, beautiful and a work of art—admittedly a fallacy—than concerned to establish the essentially formal basis of beauty in design. Moreover, his particular references to the artist suggest an individual external to industry—a talented humanist to whom the manufacturers come for a little culture and refinement.

appendix B

THE PICK REPORT

As a result of a recommendation made by the Gorell Committee, the Board of Trade set up, in January 1934, a Council for Art and Industry "to deal with questions affecting the relations between art and industry." This council, whose chairman was Mr. Frank Pick, has issued several reports, the most important of which is entitled *Design and the Designer in Industry* (1937). As its title indicates, this report deals generally with the subject of design and industry, with particular reference to the recruitment, training, and position of designers. The general principles which are laid down in the report agree in the main with the views put forward in this book. Its detailed recommendations consist of pious hopes and gentle exhortations rather than detailed plans for reform. The following extracts from the official Summary of the report show the nature of its more specific recommendations:

The weakness of most industrial concerns in the matter of creative design is due to the fact that they usually recruit their design-room staff from the elementary schools and content themselves with a design-room training supplemented by evening classes, and that they rarely appoint to the salaried staff highly qualified students who have received a full-time art training. Manufacturers are invited to reconsider their system of recruitment and training. Inside and outside sources of design are necessary, and the best use cannot be made of the contributions of

part-time craftsmen and artists unless the internal design-room staffs (as well as the administrative and technical staffs) are improved by fuller training, and unless more designers with a full-time art training are appointed to vacancies in the design room (paras. 28-33).

Distinguished artist-craftsmen, or artists and architects, who have had no specific experience of industrial art but are willing to educate themselves thoroughly for the purpose, might be employed as visiting or consulting designers for two or three months annually, where conditions do not lend themselves to the full-time employment of a highly trained designer. It will be necessary for industrialists to give active help to these part-time advisers while they obtain industrial experience, and to pay them at relatively high rates (paras. 34-36).

Experience abroad has shown the value to industry of contributions obtainable from yet another source, viz.: the free-lance designers who attend specifically to the requirements of industry. Many of our industries would benefit if manufacturers cultivated a close relationship with these designers, paying them generously, and helping them to acquire the necessary experience, so that they may be able to establish efficient studios for the service of industry, on Continental lines (paras. 37-39).

Under present conditions the work of the design room is mainly routine work, and the staff is largely trained by a process of inbreeding which in these days of mass-production is rarely satisfactory. The work tends sometimes to be prepared in ignorance of the methods of manufacture, and it may even happen that the person who prepared the paper sketch never sees the finished product. Designs should always be prepared by highly competent designers who understand the machine and are responsible for the

final form of the design. The design-room staff, and especially the senior members, need contact with outside life. Some of them should be sent to exhibitions and displays, under proper direction and after previous training, and to London and other commercial centers, here and abroad, to see the shops and make contact with the distributive and marketing sides of industry. The factory training by itself under modern conditions is insufficient. Close co-operation is required between industry and the art school in selecting and training design-room staff, and large industries should then possess a number of efficiency design rooms working in harmony with the art schools, and in close touch with the best design developments of the world (paras. 44-57).

No effort should be spared by the art schools to impart improved taste and a wider understanding of art to the part-time pupils who come to them from factory design rooms. Industries should seriously consider a scheme for releasing the design-room staffs for this art instruction during working hours, as certain industries are already doing for technical instruction, and the art schools should provide appropriate day courses for them. Evening classes are not likely to yield the best results (paras. 77-78).

It is for the factory and not for the art school to impart to these part-time pupils the necessary experience of the methods and processes of manufacture. But their art-school training should have a direct bearing on their work in the factory. The factory and the art school should realize that they are engaged in a joint enterprise with a common aim (paras. 79-81).

It is desirable that employers should occasionally release from the factory for a longer period—e.g., to attend the Royal College of Art, the Central School of Arts and Crafts,

or a selected art college—any quite exceptional employee who, in the opinion of the local art school, is likely to benefit by whole-time art education (para. 82).

When nonindustrial pupils are being trained whole-time at an art school to enter industry as designers, or to practice as artist-craftsmen or free-lance designers in industrial art, the school must impart some understanding of industrial requirements and some technical knowledge. But industrialists will be wise not to expect such pupils to establish their full position as designers in industry until they have had at least a year's experience of working conditions in the factory (paras. 83-84).

When industrialists give more attention to design and designers, and secure the designers better pay and prospects, there will be some increase in the number of students coming forward to take a full and advanced training in Industrial Art. It will then be for the art schools and colleges—whose courses for the purpose probably need revision—to consider how best to train a limited number of selected students who will bring into being a body of designers and artist-craftsmen capable of sustaining an international reputation. Full-time courses specifically directed toward the career of a designer have not been developed here on the same scale or with the same quality as on the Continent. Whether or not the creation of a certain number of monotechnic institutions will be found in due course to be necessary for the purpose, the immediate reform needed is the fuller development in the existing schools, or in the proposed art colleges, in close co-operation with industry, of appropriate courses for future designers, organized with specific regard to the practical requirements of their industrial work. The proposed new art colleges will provide for the needs of the predominant staple

industry of their locality. The closest co-operation between the art and technical schools is required, to secure that the student's course has a real unity, and it is important to provide adequate equipment and a highly qualified staff in full sympathy and contact with the industrial life of the locality and, as far as possible, actually engaged in part-time designing for local industry. The grading of students is essential, and the imposition of an efficiency test before admission to the higher courses at the new art colleges, which should not be the old art school under a new name, but institutions with a real width of outlook, constant emphasis on research, and interest in all developments likely to improve industrial design (paras. 85-96).

The local art colleges should be actively supported by industrialists, and should become a real part of the organization of the local industry serving as a focal point for the exploration of the aesthetic problems of the industry and as a center for industrialists and designers, and equipped with books, photographs, periodicals, and a reading room (paras. 97-98).

Courses of instruction are required for travelers, buyers and salesmen, and some special course might be devised for heads of firms, managers, and persons likely to rise to managerial positions (para. 97).

The most gifted of the students so trained should proceed to the Royal College of Art (para. 99).

appendix C *

THE COUNCIL OF INDUSTRIAL DESIGN

The Council of Industrial Design, with its Scottish Committee, was set up in December 1944 by the President of the Board of Trade. The Council is financed by the Government, and its annual report is made to Parliament.

The purpose of the Council is to promote by all practicable means the improvement of design in the products of British industry from capital goods at one end of the scale to fashion goods at the other, including those produced in quantity by machine and in detail by handwork. Good design is taken as meaning both beauty of appearance and practical convenience in use and manufacture together with good quality of materials and workmanship.

The problem of raising standards of design is treated broadly as one of Supply and Demand and this is reflected in the two main staff divisions: the Industrial Division to stimulate a supply of well-designed products from industry, and the Information Division to stimulate a public demand for better design.

The original instructions of the Council included the promoting of Design Centers in different industries to be supported by contributions from industry and grants from the Exchequer, the holding of selective exhibitions such as "Britain Can Make It" in 1946, and "Enterprise Scotland" in 1947, advice to Government Departments on the design

* Adapted from a prospectus issued by the Council of Industrial Design.

of goods purchased and on the selection of British goods for showing on Government stands in international exhibitions, and collaboration with educational authorities in the training of designers and in teaching design appreciation. The Council was also given the responsibility for the selection of all industrial products shown at the official Festival of Britain 1951 exhibitions.

THE COUNCIL'S SERVICES

The Industrial Division has the main responsibility for the organization of exhibitions. Such work includes:

 (a) The calling of discussion groups with trade and industrial interests to learn from industry of those developments which should be included in exhibitions.
 (b) A survey of current production and industrial developments by the Industrial Officers of the Council.
 (c) The compilation of an illustrated index of the best products in the various industrial categories.
 (d) The setting up of Industrial Panels to advise on the final selection for exhibitions.

Design Advice and the Record of Designers. Inquiries are invited from manufacturers wanting advice on product design and design policy or the services of a designer. Up-to-date records of qualified designers are maintained and also of competent photographers of industrial products.

Design Development. Manufacturers and designers requiring information about materials and processes are invited to submit their problems and they will be put into touch with appropriate sources of technical advice.

Designers who have a new idea for a product are

offered assistance in placing their design with a suitable manufacturer. In some cases this will be facilitated by the M-Service, under which the Council guarantees the cost of a model or mock-up.

Design Centers. Assistance is offered to representatives of industrial interests who wish to establish centers for joint activity on design problems. Such centers may serve one industry nationally or several centers regionally; and their work can cover research and intelligence on design problems which arise from within the industry or from consumer needs.

The Information Division uses a wide range of publicity material in its drive to raise public interest in higher standards of design. It produces films, film strips, wall cards and charts, mounted sets of photographs, portable exhibitions, inexpensive booklets, and monthly Design Folios, all of which are available to any organization interested in education and design appreciation.

"Design." The Council issues a monthly journal. It is produced primarily for manufacturers, retailers, and designers, but subscriptions are welcomed from anyone interested in industrial design. This illustrated magazine reviews developments in the decorative, craft-based, and engineering industries and carries regular features on foreign trends and products.

The Information Division offers its services to three main groups in the population—the younger generation through the schools and youth clubs, the retail and distributive trades, and those voluntary organizations in the country which are best equipped to promote an interest in design. The program of Design Weeks, with the traveling exhibition Design Fair, has introduced the subject and the Council to a wide audience.

The Education Section keeps close contact with teachers and educational authorities and is prepared to mount small exhibitions of teaching material at appropriate conferences and courses. The Panel of Lecturers provides a record of speakers on design, and recommendations are made from this.

The Retail Section works closely with the trade and offers help in staff training in design, in display, and with small exhibitions.

The Exhibitions Section stages exhibitions of many kinds, both in London and the provinces, and co-operates on invitation in officially sponsored exhibitions abroad. A regular series of exhibitions is held in the Council's headquarters exhibition hall in Murray House.

The Press Office is responsible for editorial policy not only about the Council's work but about any activity calculated to raise the standard of British design.

The Library offers books and periodicals, both British and foreign, on free loan and all inquiries are welcomed.

The Photographic Library has over twenty-five thousand different photographs and one thousand slides—the largest collection on all aspects of design in the country. The files are open for consultation without charge by lecturers, designers, journalists, and businessmen. Prints and slides may be borrowed for a small fee.

INDEX

bold numerals refer to illustrations by figure number;
light numerals refer to page numbers